Judi E Rideout

WOLF WALKING

IILLUSTRATIONS BY **JUDI RIDEOUT**

TEXT BY **EDWIN DANIELS**

FOREWORD BY **JIM BRANDENBURG**

WOLF

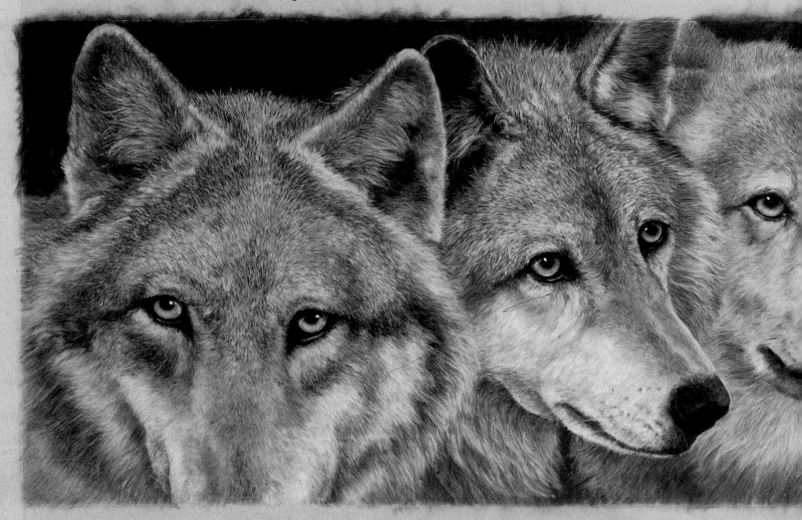

WALKING

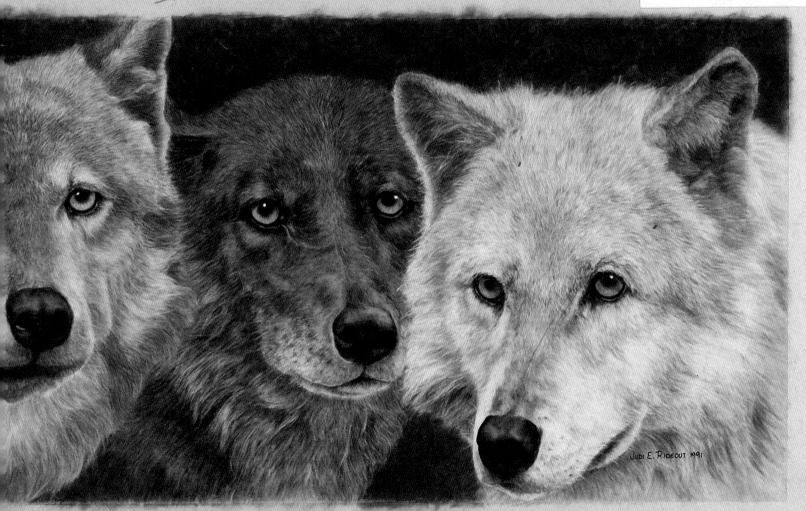

Judi E. Rideout 1991

STEWART, TABORI & CHANG
NEW YORK

TEXT AND ILLUSTRATION ·CREDITS

Kamlugyides and the Wolf (Nass River) reprinted with permission of The Canadian Museum of Civilization from *Totem Poles* by Marius Barbeau, Volume 1, pages 259-260.
Illustrations on pages 7, 8, 10, 12, 23, 24, 28, 31, 32, 33, 34, 39, 40, 41, 44, 45, 46, 47, 55, 60, 61, 71, 83 by Ernest Thompson Seton courtesy of the Seton Memorial Library, Cimarron, New Mexico.
(Additional illustrations by Ernest Thompson Seton originally appeared in the artist's book *Two Little Savages*, published by Doubleday Page and Company, 1903.)

Mexican wolf recovery excerpts provided by David R. Parsons, Mexican Wolf Recovery Coordinator, U. S. Fish and Wildlife Service.
Red wolf recovery excerpts provided by V. Gary Henry, Red Wolf Recovery Coordinator, U. S. Fish and Wildlife Service.
"Trail of an Artist-Naturalist," by Ernest Thompson Seton, excerpts reprinted with permission from Dee Seton Barber.
Topsell's Histories of Beasts, by Malcolm South, excerpts reprinted with permission from Nelson - Hall, 1981.
Wolf A False Memoir, by Jim Harrison, excerpt reprinted with permission from Bantam

Doubleday Dell Publishing Group, 1971.
A Sand County Almanac by Aldo Leopold, excerpts reprinted with permission from the Oxford University Press.
"The Nostomaniac," by Robert Service, excerpts reproduced courtesy of the Robert Service Estate.
Never Cry Wolf, by Farley Mowat, excerpts reproduced with permission from Farley Mowat.
Of Wolves and Men, by Barry Lopez, excerpts reprinted by permission of Sterling Lord Literistic, Inc. Copyright © 1978 Barry Holstun Lopez.

JACKET FRONT
Snow Wolf

JACKET BACK
Eyes of the Hunter

HALF TITLE PAGE
The Encounter

TITLE PAGE
Unity

OPPOSITE PAGE
Unity II

Designed by Nai Y. Chang
Design Assistance: Lisa Vaughn
Editorial Director: Linda Sunshine
Editors: Alexandra Childs, Enid Stubin
Production: Alice Wong

Printed in Singapore

10 9 8 7 6 5 4 3 2 1

Text copyright © 1997 Edwin Daniels
Illustrations copyright © 1997 Judi E. Rideout

Published in May 1997 by
Stewart, Tabori & Chang,
a division of U.S. Media Holdings, Inc.
575 Broadway, New York, New York 10012

Distributed in Canada by
General Publishing Co. Ltd.
30 Lesmill Road, Don Mills
Ontario, Canada M3B 2T6

Distributed in Australia and New Zealand by
Peribo Pty Ltd.
58 Beaumont Road, Mount Kuring-gai
NSW 2080, Australia

Distributed in all other territories by
Grantham Book Services Ltd.
Isaac Newton Way, Alma Park Industrial Estate
Grantham, Linconshire NG31 9SD, England

Library of Congress Cataloging-in-Publication Data

Daniels, Edwin
Wolf walking / text by Edwin Daniels ; illustrations by Judi Rideout
 p. cm.
Includes bibliographical references
ISBN 1-55670-551-4
1. Wolves—North America. 2. Wolves—Behavior—North America.
3. Wolves—Folklore. 4. Wildlife conservation—North America.
5. Wolves in art—North America. I. Rideout, Judi.
 II. Title
QL737.C22D36 1997
 599.74'442—dc20

96-43284
CIP

CONTENTS

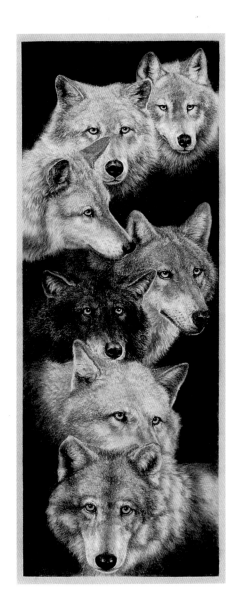

FOREWORD

Among the animals I have stalked and photographed around the world, none has so profoundly affected me as the wolf.

The primal immediacy one feels when crossing trails with a wolf or hearing the songs of a wolf pack in wild country at night is impossible to describe with words or pictures. Whatever emotion this experience arouses will be forever remembered.

The power of a wolf to evoke deep, unspeakable meaning has been the stuff of myth and legend throughout the Age of Man. Somehow, the connection with wolves has been indelibly traced deep into our hearts.

As one who has explored his own heart with the wolf as guide and companion, I know Edwin Daniels and Ernest Thompson Seton to be brothers of this primal experience. Aldo Leopold stands between the time of Seton and Daniels, between a time of killing wolves unquestioningly and a time when there is increasing fascination with the wolf and interest in its preservation. Leopold's writings were early and eloquently questioned the killing of wolves. "Only the mountain has lived long enough to listen objectively to the howl of a wolf." He shot a wolf and later wrote about the experience of watching it die:

We reached the old wolf in time to watch a fierce green fire dying in her eyes.... There was something new to me in those eyes—something known only to her and the mountain. I was young then, and full of trigger-itch. I thought that because fewer wolves meant more deer that no wolves would mean hunter's paradise, but after seeing the green fire die, I sensed that neither the wolf nor the mountain agreed with such a view.

Judi Rideout's wolf illustrations—unlike many paintings I have seen—capture this animal's uniquely expressive eyes. With eyes as the focal point in each "wolf portrait," every wolf is still clearly a unique individual, still a singularly evocative presence.

For my part, I have seen these eyes many times. From just a few feet away, I have felt the fierce aggressive stare of an alpha male defending his kill in the high Arctic. I was frightened and quickly retreated. I have seen the warm and contented gaze as a mother wolf attended two newborn pups. Deep in the forest near my cabin, I shared a nap with a sleepy eyed, young member of a new pack that does not know the lessons a rifle teaches. This moment of rare tolerance brought me back 20,000 years to a time when man and wolf formed a sacred partnership. I have also seen that fire going out in a dying wolf's eyes. She was curled up under a white spruce tree in January, her right front foot severed, I suppose, from a steel leg-hold trap. Wolves are known to chew their trapped leg off to free themselves. I had a quiet conversation with her as I crouched just three feet away under those sagging boughs in her secret dying space.

I refrain from ascribing too many emotions to Ms. Rideout's wolves, except to say that my own response to the wolf has always included the sense of a debt unpaid.

Is that sadness we see in those painted eyes...or a mirrored reflection of our own?

JIM BRANDENBURG
Ravenwood Studios, 1996

INTRODUCTION

My tent, a thirty-year-old relic of cerulean canvas, hangs heavy and wet on its aluminum posts. A raging thunderstorm exploded in yesterday's hot afternoon void and battered my camp all night long. Wind, rain, and random voltage drove me from the blue canopy and into the dry confines of my vehicle. But the storm also transformed this expanse east of the Chihuahuan desert, with its endless bajadas and towering limestone bluffs, into a verdant mirage. The green will last until the day's heat casts the desert into torpor. By evening, my tent will dry and the landscape will succumb once again to the russet cloak of deep summer.

Not far from my camp, the Devil's River cuts through the dry Texas west on a leisurely journey to the Rio Grande. The name is a misnomer, for the river is a cool vein of life intersecting an otherwise parched and thorny ground. The limestone cliffs banking the river and its tributaries harbor hundreds of Native American shelters. Their pictograph-covered interiors speak of lives and dreams and magic unfamiliar to the modern eye. Shamans, beasts, and ritual markings decorate the stone. But their meanings are buried with their creators beneath layers of silt and crumble.

Gone, too, are the wolves. The animals met with constant animosity until they were exterminated. Efforts to extirpate the wolf from the Texas southwest mirrored those used to drive the Indians from their sacred shelters. The campaigns left only artifacts to analyze, bones to measure, and interpretations to approximate in a piecemeal landscape corrupted by naive abuse. But it is not so much the loss of meaning and dignity and ecological harmony that is to be mourned in this country—it is the loss of the spirit that once made this place a true wilderness.

EDWIN DANIELS
Texas, 1996

Where will you and I sleep?
At the down-turned jagged rim of the
sky you and I will sleep.
WINTU

Peace Pipe

RIGHT
Winter Watch

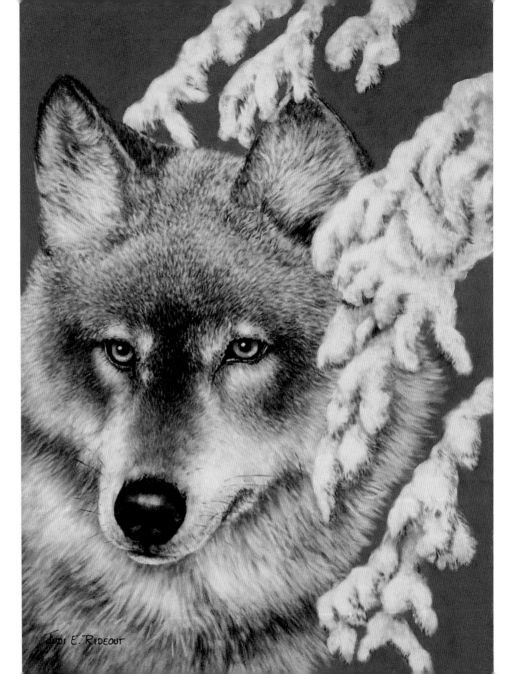

I
THE DOWN-TURNED JAGGED RIM OF THE SKY
Wolves and Wolf Behavior

A black flock of ravens wrestles among the branches of an evergreen spruce. The trees dot the broad, frozen Alaskan valley and poke awkwardly through the white winter crust. The birds flick their wedge-shaped tailfeathers and crack the air with long, drawn-out caws. They are resting, idle, waiting for the wolves to arrive.

Pentacles of stone rim the valley's horizon. The massive tumult of crests and peaks are known collectively as the Alaska Range. Above it rises the monarch of the entire North American continent, Mount McKinley. The Athapaskan Indians christened it Denali—the High One.

During the summer months, the mountain reigns over a verdancy wet with the milky run of melting ice. Wolves pause to drink from the streams, creeks, bogs, swamps, shallow lakes, and ponds that capture the melt as it moves sluggishly through this warm green valley beneath the mountain's shadow. But throughout the long frosted winter, the wolves travel above the pickled grasses and crimson spikes of fireweed that lie imprisoned beneath heavy sheaths of ice and snow.

Wolves entered this landscape after an extended journey, beginning over

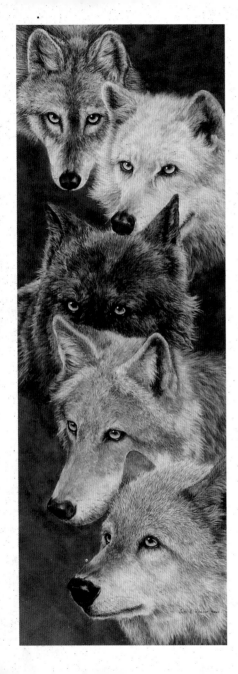

LEFT
Canadian Five

RIGHT
Tundra Mates

OPPOSITE
Eyes of the Hunter

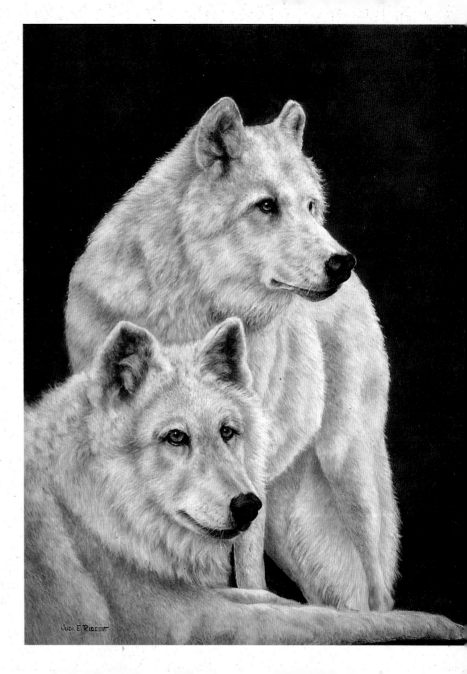

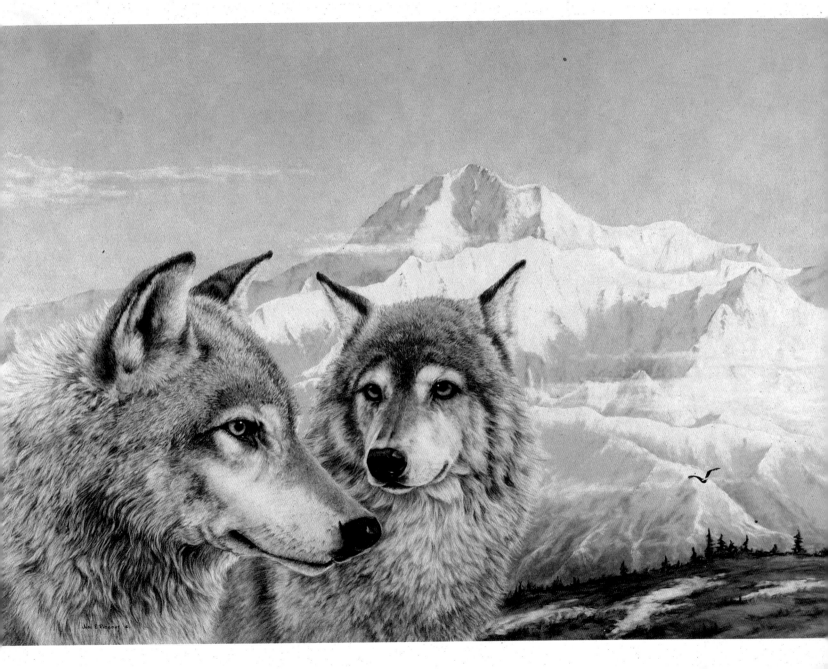

Pack Member

RIGHT
Archer's Grip and Arrow

one hundred million years ago. Creodonts, a primitive group of meat eaters, roamed the northern hemisphere, slowly evolving into bears, cats, weasels, raccoons, civets, hyenas, foxes, and dogs. The wolf is the largest member of the dog family, and it finally evolved, much as it exists today, between one and two million years before the present. Its role as predator—hunting, killing, and eating mammals often much larger than itself—fills an imperative niche in the living ecology of this frozen north.

The ravens chatter noisily as a ranging pack of wolves move forward with concentration, purposeful and attentive. The pack's movements through the winter cycle have been significant, covering many miles per day, using game trails, windswept ridges, and frozen waterways packed solid with ice. They are hunting and their technique is simple—they travel until they come upon vulnerable prey.

Very little is known about the size of a wolf pack's winter range. It has been recorded at anywhere from fifty to five thousand square miles. The range may depend on adjacent and overlapping ranges of other packs, the size of the pack, or the density of animals preyed upon by wolves. But whatever the parameters, wolves are compelled to travel by their need to eat. When they are traveling, they are also hunting.

The ravens rearrange themselves along the evergreen branches droopy with snow. The branches quiver beneath the weight and drop kernels of freeze to the ground. The tick, tick, tick of ice on ice alerts three browsing moose nearby to raise their heads. Upwind, the moose can only pause in trepidation, then hang their heads above the snow.

The moose is a favored meal for wolves, among deer, caribou, elk, and Dall sheep. Wolves have also been known to feed on beaver, rabbits, mink, muskrats, squirrels, mice, birds, fish, lizards, snakes, insects, worms, wild berries, and carrion. Given an opportunity, wolves will consume an assortment of domestic animals as well, including cattle, horses, sheep, pigs, cats, and dogs. In their predation, wolves tend to focus on species of large mam-

mals that present the least challenge. Prey disabled by youth, malformity, sickness, old age, malnourishment, wounds, surprise, or stupidity are all targets for a pack of wolves.

A sharp breeze wafts across moose hide and travels downwind. The lead wolf suddenly stops. The pack responds, directing nose, eyes, and ears toward the scent. They wait for the alpha male, the lead hunter, to move. It is their nature to defer to their leader and an integral part of their group behavior. Wolf packs adhere to a special hierarchy where dominance and submission are the rule. Within this system, a gender order exists led by an alpha male and an alpha female. As a breeding pair, they form the basic foundation of the pack. All other wolves in the pack will defer to them. This dominance order descends through the pack, winding its way down to the last and most subordinate animal, and is expressed through passive or active submission. Wolves display passive behavior when they feel minimized by or helpless before dominating pack members. But active submission is an expression of temperance, affection, and group accord.

The pack is a family group, and it likely consists of the breeding pair and their first- and second-year offspring, particularly in a newly formed pack. Often a pack will include additional breeding adults and accepted members from other packs, increasing the pack size to as many as twenty or thirty wolves. But the size of packs vary, often relying on available prey, an acceptable level of competition within the pack, or the ability of each pack member to develop emotional bonds with all other members.

Bonding is an integral part of pack development. This ability to connect emotionally is perhaps the wolf's strongest trait and forms the basis of pack evolution, holding the pack together. Each member connects with the other, making these bonds the foundation of the wolf social structure. Packs consist of groups of individuals hunting and eating cooperatively, traveling over great distances, and resting together. For this system to work effectively, it requires collaboration, leadership, submission, and psychological ties.

On the ragged edge of the world I'll roam, And the home of the wolf shall be my home.

ROBERT SERVICE
"The Nostomaniac"

The pack gathers around the alpha male, pushing their noses together, licking the alpha male's face, gently mouthing and nipping his muzzle. He is a significant creature, measuring six feet from the end of his nose to the tip of his tail. He weighs close to one hundred pounds. He walks on his toes and can swim and tread water. His teeth number forty and are efficient tools for clamping, ripping, tearing, and shearing meat and for breaking, gnawing, cracking, and crushing bones. His fangs are his jaws' most prominent feature and reach two and a quarter inches in length, including the segments embedded in the flesh. They are piked, sharpened, and effective in clinging, slashing, and puncturing. The wolf's olfactory senses are acute, estimated at up to one hundred times more sensitive than those of humans. His pelt appears white, but within it lie shades of gray, red, and brown, the pelage of his species providing more variety than almost any other. His brain is highly developed, indicating that he and his species can learn, remember, and make associations.

The alpha male tests the air once again and moves off the travel route. The pack of sixteen wolves follows, becoming excited, tails wagging, eyes dead ahead. They are eager to cut loose in full run, but they refrain, forming a single file through the snow, accelerating their pace uniformly, disciplined by some internal restraint.

The ravens watch them crest over a winded drift. The birds shift nonchalantly, gleaning feathers. Their quiet movements fail to alert a lone moose less than a hundred yards away. The moose's companions have moved farther upwind, not quite out of sight. It stands alone in the snow, fortified only by its sheer size—weighing close to a thousand pounds—and the ability to strike with its hooves. If the circumstances were different, it might consider fending off an attack by standing its ground. But the sudden proximity of the wolves takes the animal by surprise, and it bolts.

Running prey is an invitation to the chase. The pack charges directly for the animal, covering the distance with tremendous speed and agility. The wolves surround the moose, attacking its rump and shoulders. The ravens

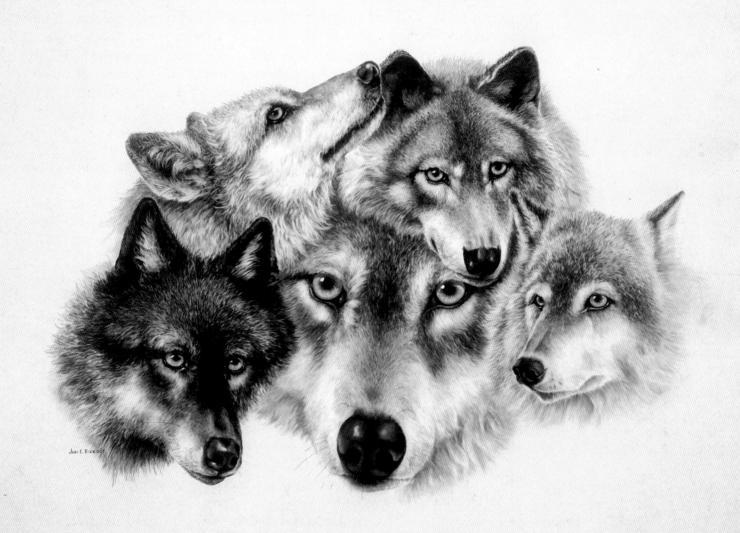

Lucan

catapult into the air and whirligig above the commotion excitedly. The moose backs out of the attack, kicking and bleeding from the flank. It manages fifty feet before the wolves are upon it, lunging at its back and throat. The moose continues forward, dragging the wolves as they cling to its flesh. The animal collapses momentarily, then rises, shaking off the attackers, standing at bay beneath the boughs of spruce.

Ravens strafe the churned ground, feeding on the bloodied snow. The wolves continue to harass the wounded prey, driving it from the evergreen shelter. The alpha male seizes the moose by its nose, and several more wolves tear at its throat and neck. The remaining pack slashes at the traumatized rump and flanks, avoiding the moose's failing attempts to dash their heads with its hooves. The moose is finally pulled to the ground and does not get back up.

The wolves gather around the carcass, ripping and pulling chunks of meat. The pack has not eaten for several days. The wolves are capable of consuming almost twenty pounds of meat apiece at each meal. Very little time is spent chewing. Their saliva lubricates the bulks of flesh and skin, which are swallowed whole. The lacerated flesh of the moose's rump is eaten first. Consuming the flanks and rib cage provides access to the body cavity where the heart, liver, lungs, and viscera are devoured. Almost everything will be eaten—lips, ears, windpipe, tongue, hide, flesh and fat—except for the prey's stomach contents. Ultimately, if they are left undisturbed to feed, the wolves will leave little to remain in the wild.

Once the wolves have eaten their fill, they retire close by to rest. The wolves' activities for the next several hours are limited to relaxing, sleeping, and halfheartedly taunting the ravens stealing bits of tattered prey.

A subordinate male wanders over to the carcass, extracts a bone, carries it back to the vicinity of his fellow wolves, and begins to chew. The alpha male approaches and attempts to procure the bone, but the subordinate wolf growls and bares his teeth, his forehead wrinkled, ears erect and pointing forward. The alpha male retreats and leaves the wolf to his bone. The behavior

is an exception to the dominance rule, defining indisputable possession as anything within a foot or so of the wolf's jaws. Wolves communicate this ownership and other information to each other by coordinating body posture with facial expressions, tail position, and voice.

Wolves will use a number of additional physical cues to communicate, such as changing their breathing rate, causing their hair to stand erect, and dilating or enlarging their pupils. But the wolf's head is perhaps its most expressive feature. The wolf will contort its facial muscles, eyes, ears, nose, snout, lips, and forehead in a variety of combinations to express its message. To threaten, the wolf will bare its teeth, open its mouth, and pull the corners toward the fangs, swell the forehead, harden the ears, and point them forward. The animal will indicate submission by closing the mouth and pulling the corners back, smoothing out the forehead, drawing the eyes to slits, and folding the ears back to the head. These changes in the wolf's features can be combined with the position of the tail.

The tail can signify emotions as well as status by its shape, positioning, and the way it moves. A tail raised above the back or perpendicular often indicates a threatening wolf. A submissive wolf will hold the tail low and tuck it between its legs or along the side of its body. Add the side-to-side movement of the tail in these positions, and the meaning is altered.

A wolf will whimper, growl, bark, and even squeak. But the howl is the wolf's notorious voice and perhaps its most mysterious. Howls can be heard several miles away, and variations have been detected in individual wolves. Very little is known regarding its significance. Wolves will howl at the full moon just as readily as at high noon. Wolf packs have been observed responding to the howls of other packs, and biologists suggest that this behavior is designed to communicate the presence and perhaps the territory of a wolf pack. They also suspect that howling is utilized to assemble a dispersed pack. Once distinctions were noted and recorded in individual howls, scientists began to consider the possibility that a wolf's howl aids in identifying the animal to other pack members. But whatever function a howl serves, the wolf

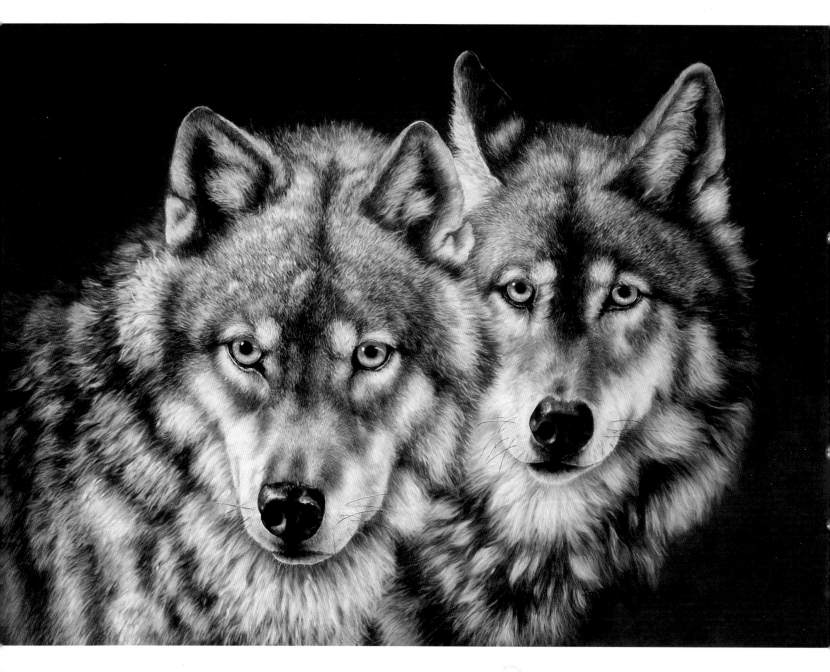

pack is inclined to join in a group howl and will do so without much coaxing from an inspired member. No particular time of the day seems any better or worse than another, and a friendly camaraderie, tails wagging, appears to accompany the infamous chorus.

The light hangs drowsily above the pack, the late winter sun a dim orbit never quite fully awake. The alpha male nuzzles his mate and she responds, rubbing his head and gently mouthing his snout. She pushes her nose through his fur, drawing the skin with her breath. Her devotion is clear and without hesitancy. Once she grew into her sexual maturity at twenty-two months, the alpha female helped define and now aggressively defends her role as the leader's mate. She and her species have entered the breeding season and some of her time is spent fending off other males and rival females, maintaining her position as second in the pack. The pair's initial courtship began many months before they first mated and has resulted in two seasons of pups.

Existing evidence indicates that most wolves engage in devoted and long lasting relationships. The courtship period may last up to a year, with the wolves focusing on their chosen mate. Advances by other wolves are typically rejected. In addition, both the alpha male and female will often interrupt the courtship and mating behavior of other males and females in the pack. But despite the selective preferences, rejections, and disruptions, a minor percentage of courtships eventually succeed in sexually mating pairs.

The alpha male rises up and circles his female playfully. He wags his tail and lowers his head and chest to the ground. The female extends her forepaws across his shoulders and buries her snout in the fur of his neck. Nipping her ears and face, the male mounts her side. She turns her tail to him and raises it, whimpering gently, swinging her sex in a subtle rocking motion. The alpha male is upon her and inside her, thrusting forward, backward, then moving sideways, with weight first on one hind leg and then the other, setting the sexual tie. After several more thrusts, he ejaculates.

Intercourse between wolves has its obvious purpose. But the sexual tie

Next Generation

TOP RIGHT
First Light

BOTTOM RIGHT
Den Pup

itself is still a mystery. The male and female may remain physically attached for as long as half an hour. It appears that, once ejaculation has taken place, the male will position his front legs beside hers, lift a hind leg over her back, and turn away. They often settle this way, back to back, resting upon the ground while pack members linger around them with interest.

It will be sixty to sixty-five days before the wolf bears her young. She will complete the den preparations perhaps three weeks before she gives birth to an average litter of six pups. Depending on what she can find in the wooded thaw, she will either create her own den or expand the hole of another animal, occupy an abandoned beaver house, use the hollow base of a tree, a hollow log, a cave, or simply choose a shallow bed. Or she may return to an established den if it has not been disturbed. She will try to choose a location near water. She will need a large quantity per day while she is nursing. If a den is dug, it may have a great deal of soil near the entrance and a network of trails leading from the site. The opening may measure up to two feet in diameter and tunnel into the earth as far as fourteen feet. The tunnel leads to a grotto where she will sequester her newborns.

The female wolf gives her pups almost constant care for the first few days. Reclining on her side, she keeps them beside her while they nurse or rest. The newborns are deaf as well as blind and seem to have almost no sense of smell. But they can crawl. Occasionally, the whining newborns may wander down the tunnel. The female wolf will relinquish her station, retrieving the pups by gently lifting them with her mouth. She grasps them either by the neck, the back, the belly and hind leg, or by the complete body. Their furry features are irresistibly charming, with rounded heads topped by tiny ears and a pug nose. If placed on a scale, they would each average one pound. They can taste food, feel heat and pain. They can lick, suck, and yelp. For the first few weeks they feed on their mother's milk. Then, after three weeks or so, the pups will venture outside the den and feed on partially digested meat.

The female wolf may travel a short distance from the den to feed on

Inescapably, the realization was being borne in upon my preconditioned mind that the centuries-old and universally accepted human concept of wolf character was a palpable lie. On three separate occasions in less than a week I had been completely at the mercy of these "savage killers"; but far from attempting to tear me limb from limb, they had displayed a restraint verging on contempt, even when I invaded their home and appeared to be posing a direct threat to the young pups.

FARLEY MOWAT
Never Cry Wolf

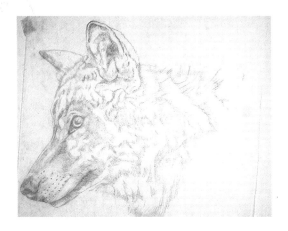

Alpha Female

meat which has been hidden or partially buried by her or other pack members. Upon her return, the pups will tumble around her, sniffing and nuzzling her mouth. This behavior is believed, in the case of mother and pups, to establish the basis of active submission in the wolf's social structure. The female wolf responds to this behavior by disgorging the predigested meat, which the pups immediately consume.

But she is not the only wolf in the pack to provide this service to her pups. Other adult pack members will feed the pups, as well as care for and interact with them, making the raising of young a group activity. As this interaction begins to take place, the pups develop emotional attachments to their fellow littermates and all pack members. These bonds form rapidly and grow stronger as the pups mature. They establish behavior patterns and dominance relationships. Their physical abilities improve. The wolf pups begin to run, chew, jump, wrestle, snap, growl, bite, and howl. They also begin to display predatory behavior.

Despite traditional belief, wolf pups are probably not born with the impulse to kill. Instead, they are born with specific behavior patterns which provide a gateway to predatory skills. Tugging, chewing, and vigorous shaking of hide strips, chasing small animals and nipping at their hind legs, pouncing, snapping at meat, and aggressively skinning bark from tree limbs are all inherent actions for the wolf pups. They understand how to utilize this behavior by taking part in adult activities, particularly hunting and killing prey, and learn quickly to associate killing with eating. But it is a wide gateway to predation for the wolf. Even without peers to imitate, the animal may need little encouragement to kill.

The pups will not mature until late into their second year, but by six months old, they will look much like the adults that bore and raised them. If they survive the rigors of the natural world, including parasites, rabies, cancer, arthritis, injuries, infection, malnutrition, or exploitation by the one predator that can exact the greatest damage—humans, the wolf may live for ten or fifteen years. But the precise life span of wolves in the wild, like many

things about their habits and the wilderness they share, remains unknown.

The wolf pack stirs. While the wolves have been resting, a canopy of clouds has rolled over the landscape, mirroring the ground in a leaden haze. Small flakes tilt in the air, then float downward, cloaking the wolves' thick pelage with a delicate shadow of lace. The ravens perch in the stillness, shaking fresh snow from their napes and crowns. It has been six hours since the wolves' initial meal, and they begin to drift back to the prey and feed. Eventually, all that remains of the carcass are shattered ribs, vertebrae, and joints, tough strips of freezing hide, and tenacious flesh clinging to the bone; enough to feed scavengers, a cache for the fox and the wolverine. Once sated, the wolves assemble in the peculiar habit that is all their own. With encouragement from an inspired member, they point noses to the icy ceiling and begin to howl.

Once the chorus has ended, the wolves follow the inclination of their leader, moving westward into a veil of falling snow and the penumbra of darkness. The echoes of their voices linger among the evergreen boughs laden with sated ravens. The birds remain bound to the branches, unhurried and at ease. They rest and dawdle, assured that, as day follows night, they will eventually take to the air and accompany the wolves to their next meal.

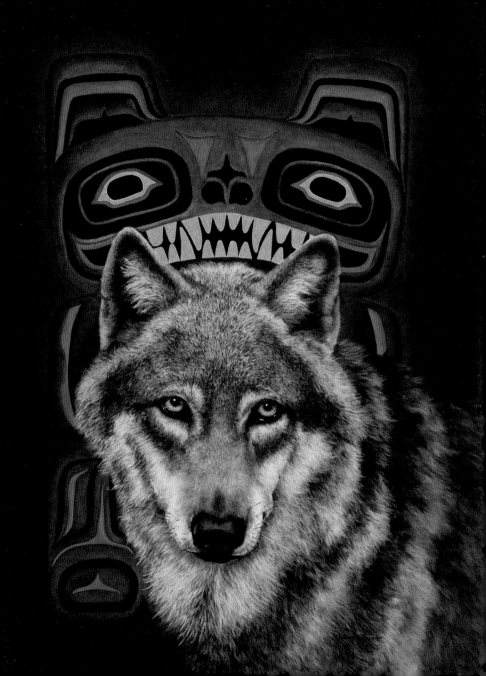

Down west, down west we dance,
We spirits dance,
We spirits weeping dance.

WINTU

RIGHT
Spirit of the Wolf

II
WE SPIRITS DANCE
A Mythology of Wolves

High above the American plains, ten thousand feet up the Big Horn
Mountains in Wyoming, an ancient earthwork called the Medicine Wheel
circles a field of prairie grasses. This wheel, a spoked ring of piled limestone
over five hundred years old, is more than just a sacred ceremonial site for
many Native American tribes. It is their church, their United Nations and,
located just one hundred miles east of Yellowstone, it marks the traditional
heartland of the wolf.

The world surrounding Medicine Wheel is enormous. The sloping
vistas and careening heights stretch the horizon of land and sky. Beings who
choose to walk across its earth succumb to an unrelenting power. The air
keens in an aggressive wind and the sunlight illuminates, then shadows, the
hidden secrets of the terrain. It is believed by many to be a sacred place, a
land populated by the animal spirits. It is here that the wolf spirits wait
patiently for safe passage. And when the time is right, they come down from
the mountains as if from the sky. And all the wolves trapped and poisoned
and shot dead by a witless past are born again.

The land of the dead and the celestial heavens are familiar places for
the wolf to walk. The eyes of the Pawnee watch the wolf's birth and death

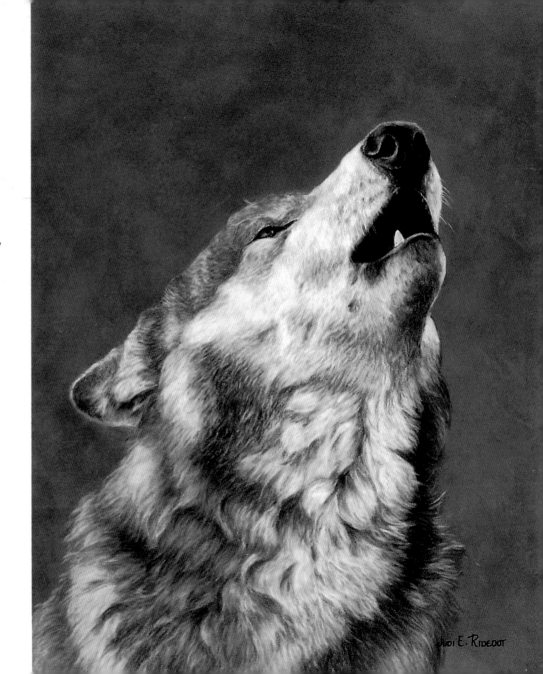

The wolf's howl is the social signal perhaps most familiar to everyone. It typically consists of a single note, rising sharply at the beginning or breaking abruptly at the end as the animal strains for volume. It can contain as many as twelve related harmonics. When wolves howl together they harmonize, rather than chorus on the same note, creating an impression of more animals howling than there actually are.

BARRY LOPEZ
Of Wolves and Men

Wolf Song

each evening in the night sky. As the brightest star on the southern horizon, the Wolf Star Sirius rises and sets in a realm more ancient than the line between earth and clouds. The wolf comes and goes from the spirit world, traveling down the Milky Way, called the Wolf Road. It is an honorable trek for the wolf to make, an arc of gratitude for the earth's first creature to be killed and the first to return from the dead. The Pawnee creation legend tells the story:

When the time had come to create the earth, a great council was held and all the animals were invited except Wolf Star. He resented this treatment and looked for ways to express his anger. He began to watch the Storm That Comes Out of the West, who was responsible for traveling the world and seeing that all went well. In his travels, the Storm That Comes Out of the West carried a whirlwind bag in which he kept the first people. Every evening, he would stop and release the people and they would camp and hunt.

Seeing an opportunity, Wolf Star sent a gray wolf from the sky to steal the whirlwind bag. While Storm was asleep, the wolf took the bag and ran far away. He finally opened it, thinking he might find something to eat, and the first people came out and set up camp. But they quickly realized there were no buffalo to hunt. When they discovered that a wolf had let them out instead of Storm, they became angry and killed the wolf.

The Storm That Comes Out of the West came upon the first people and the wolf they had killed. He told them to skin the wolf and make a sacred bundle with it, wrapping in it everything that would bring back the memory of what had happened. Then he named the first people Skidi Pawnee, the wolf people, and told them that by killing the wolf they had brought death into the world.

Wolf Star continues to rise just before dawn, reminding the people of this time and accompanied by a chorus of earth wolves as they howl skyward before the first light of day.

Native Americans created a wolf as diverse as the natural world they

The innocent moon, which nothing does but shine,
Moves all the laboring surges of the world.

FRANCIS THOMPSON

Teepee

Bull Teepee

shared. It is a wolf born of careful observation and a broad understanding of nature's complexities. Rather than a simple character capable of either good or evil, the wolf is a complicated being, excelling in strength and succumbing to weakness. Its ferocity and bravery are valuable traits to emulate. Its skill, predacious behavior, and social hierarchy are important tools in teaching lessons, gaining respect and maneuvering through life.

Up until the mid-1800s, Native Americans had abundant opportunities to observe the wolf walking through their world. A large portion of the wolf's original range extended throughout Mexico, the U.S., and Canada. Out of the thirty-two recognized subspecies of *Canis lupus*, twenty-four could be found inhabiting the North American continent, from the Mexican Plateau to the Bering Strait. It is doubtful whether any other species of wild, land-bearing mammal surpasses this dramatic expansion. Wolves, in a sense, became the most successful living example of a mammalian family surviving in the wilderness. It is an achievement embraced by all Native American tribes who came into contact with the wolf. They studied the wolf and integrated the things they learned into their stories and ceremonies. They absorbed the attributes of the wolf that made them stronger and passed these along to each succeeding generation.

The Ojibwa culture revered the wolf for its fidelity to family. The Oneida of Wisconsin admired the animal's endurance and courage. The Inuit honored the relationship between predator and prey, viewing caribou and wolf as one. Kiowas called timber wolves brothers and sisters. The Navajo empowered the wolf with magic and sorcery.

Wolves in spirit form can be found initiating young people into many Pacific Northwest tribes. The wolf ceremony is a necessary rite of passage, an essential event defining an individual's identity within the tribe. Participation is required before an initiate can take part in any other tribal ceremony. Aspects of the ceremony differ throughout the various tribes practicing the ritual. But the wolf ceremony springs from an original myth which remains essentially unchanged.

The myth begins as a young man is taken from his village by wolves. The wolves try to kill him, but the young man survives. The wolves befriend him and teach him how to hunt and how to be fierce, strong, and brave. Once the young man has learned these things, the wolves return him to his tribe where he teaches the village the lessons he has learned. This simple story illustrates the essential triumphs necessary for living in the natural world—courage over fear, knowledge over ignorance, and survival over death. It is no wonder then that stories about the wolf abound in the mythology of Native Americans.

The Tsimsyan people of the Nass River, along the coast of British Columbia, tell an unusual story of their own Wolf clan:

> Before the family of Towq moved to the upper Nass River, these Wolf people lived at Larhwelgiyaeps, on an island in the Metlakatla passage at the seacoast in front of the present town of Prince Rupert. Every night the people heard the beating of drums and singing from the point across the channel just opposite. They were frightened, for they did not know the cause of the noise—there was no village there.
>
> Despite the warnings of their elders, the young men of the village could not restrain their curiosity. Accompanied by their young prince Kamlugyides, the men set out to investigate.
>
> When they were across the river they saw a big village, in the middle of which stood a large house. It was from here that the drum beating and singing was coming. So the young men went to this house. Looking in, they saw a great crowd around the singing platform on which squatted many women. These women all wore bright garments, and the man who was dancing had on a great mask which looked like a huge skull, and a very bright robe. The others all wore death costumes and skull headdresses. When they danced there was a noise of rattling bones.

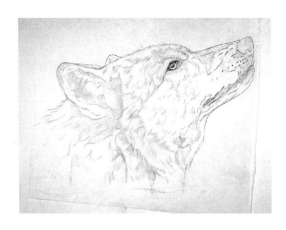

Wolf Singing

The women were very beautiful as well as good singers, so the young men from Larhwelgiyaeps decided to approach them. As their attentions did not seem to be resented, the young men became even bolder and went underneath the singing platform, which was only breast high. When they were under the women of their choice, they shoved their hands under their garments. When all they felt was bones, however, they withdrew their hands and found them nothing but bone too; all the flesh was gone. They now knew that these were ghost people. . .

The young men defeated the ghost people, taking the mask and robe worn by the chief dancer, and then returned to their village.

While in the ghost house they had heard the following names announced: Ghost-Walking-Toward-the-Rear, Hollow-Elderberry-Bush, Hollow-Roots, Moss-in-Eyes-on-One-Side. These were names of the figures he had seen at the dance. With the mask and headdress they were assumed as the exclusive property of Kamlugyides.

The village soon experienced a great famine and all its people were starving. Every day they could hear a wolf cry just beyond the village, but the people were too frightened to seek the wolf out. Kamlugyides, determined to locate the wolf, followed the animal's cries into the woods.

When he entered the woods some distance from the village, he came upon a huge wolf pacing to and fro, whining as if it were in agony. As soon as it saw Kamlugyides approaching, it laid back its ears. Kamlugyides spoke: "Come, brother, what has happened to you? Don't hurt me, and I may be able to help you." The wolf came near and Kamlugyides examined its mouth, and behold! A deer bone was stuck in its throat.

Kamlugyides removed the bone from the wolf's throat

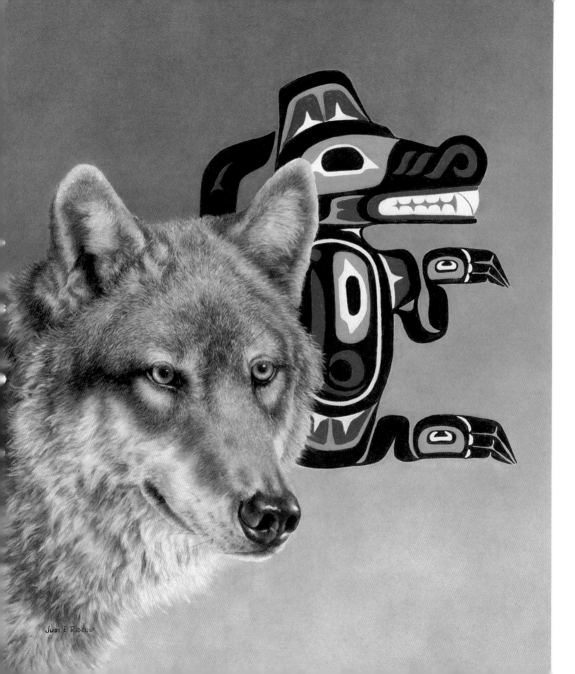

Now this is the Law of the Jungle—
as old and as true as the sky,
And the Wolf that shall keep it may
prosper, but the Wolf that shall break
it must die.

RUDYARD KIPLING
The Law of the Jungle

Wolf Spirit

and the wolf thanked him, bringing him and his villagers meat. The gifts of meat continued and the village was no longer starving. Kamlugyides began to give feasts, bringing out the ghost mask and robe and assuming the names he had heard at the dance.

Now he intended to give a final feast at which he would assume the crest of the Prince of Wolves. He went up into the woods to meet the wolf that he had befriended, and said, "I am going to call together all of the Tsimsyan chiefs and their people. Please help me!" For many days the wolf and its pack were busy bringing game, as well as mink, marten, and groundhog, which were to be distributed as gifts. When all was ready, Kamlugyides called together all of the chiefs and people of the Tsimsyan, and assumed the crest of the Prince of Wolves.

The feast was held and Kamlugyides assumed the crest of the Prince of Wolves. But dissension broke out sometime later

Drinking

regarding the ghost mask and the privilege to wear it. Much like a wolf spurned from its pack, Kamlugyides left the village, taking his family and forming the Wolf clan of the upper Nass River.

In the cool Pacific Northwest, the wolf ceremony continues to embrace and initiate the young. But southward, across a gulf much greater than the two thousand miles separating them, a wolf of a wholly different nature was being born.

It is 1835 in the arid frontier of the Texas southwest. The world here is blanched and dry, the horizon broken only by an isolated thunderhead rising from the cooked earth like a hammer above an anvil. Along a remote waterway called the Devil's River lies the isolated cabin of settlers John and Mollie Dent. The river twists through the Hades-like country of its namesake, providing the desert dwellers with a substance more precious than gold. The wolves know it well. They come to drink and howl and hunt the deer that pause in the river's respite. But on this particular evening, their howling is momentarily drowned by the screams of Mollie Pertul Dent. She lies inside the cabin in a bed of pain. With a final cry of agony, she dies in childbirth.

Her husband, panicked and distraught, is riding toward the neighboring ranch some distance away, hoping to find help. Caught in a violent thunderstorm on a dark and flat terrain, he searches for cover and finds none. In a quick and brutal flash, John Dent is struck down by lightning and killed.

Upon arriving at the Dents' cabin, the rescue party finds it empty. Efforts to locate the newborn child are unsuccessful. Despite a thorough and exhausting search, the child is never found, and it is presumed that wolves carted her tiny body away and devoured it.

Less than a hundred miles southeast of this tragedy lies San Felipe Springs. It is by all accounts a vital supply of underground water in an otherwise parched region. It is an ideal place for settlers in 1845. During this

Feet

time, many settlers began to congregate around the springs. One such inhabitant, a young boy, claims to have seen a creature that looked remarkably like a naked girl with long hair. He watched while the girl and several wolves attacked a herd of local livestock. For the next several years, additional sightings of the girl are reported. These sightings are substantiated by the claims of local Apache Indians who find footprints of a child among the prints of wolves in the area. The decision to organize a hunt is made and a party is sent out to locate the girl.

The search continues for three days, tracking the girl and her wolf companion into a box canyon. Her wolf companion attempts to attack the hunting party and is shot. The girl is then caught, tied up, and taken to a local ranch. Upon arrival, the hunting party locks her in a room.

As the evening descends, the girl begins a sad and constant howling. Packs of wolves, attracted by her cries, circle the ranch house compound. Their presence frightens the livestock, creating noise and confusion throughout the immediate area. Taking advantage of the commotion, the girl escapes under the cover of darkness.

Seven years pass before she is seen one last time. A crew of workmen are surveying the border along the Rio Grande for a stagecoach route to El Paso. They catch sight of her and watch her pause for a moment on a sand bar. Two wolf pups tangle at her feet.

The legend of the Devil's River wolf girl has become part of the mythology of the Southwest and in many ways defines the threshold between Anglo and Native American views of the wolf.

While the Native Americans worked to achieve a harmony with the wilderness around them, the Anglo-Americans pushed through the Western frontier with a slash-and-burn mentality. The wolf became just one more obstacle in a world full of hardships. Wild and dangerous, wolves did nothing for the unfortunate who fell into their midst except spirit them away beyond salvation.

This Anglo-American view of the wolf springs from the mythical

folklore of its European ancestors who imbued the animal with a particular trait or special status. The Norsemen made wolves the companions of their gods. Their respect for the wolf's strength and hunting abilities mirrored that of the Native Americans. Romans venerated a female wolf as the savior of Rome and stamped their coins with her image because they believed the city's founders, Romulus and Remus, were rescued from certain death by the tender mercies of a nursing wolf. But with the advent of Christianity, the wolf began a long decline into superstition and negative mythology.

Biblical writings made the wolf a metaphor for deception and evil. These references inspired many beliefs about the wolf, suggesting the animal exhibited unusual power over humans and fellow animals. Europeans believed that if a mare with foal walked on the prints of a wolf, she would miscarry. Men were said to lose the ability to speak if a wolf saw them. Wolves were believed never to attack humans unless the animal had tasted the flesh of the dead. A gun used to shoot a wolf was rendered useless, unable to fire again when needed. A horse availed to chase a wolf would become lame. Stories of men transforming into wolves by the light of the moon were embraced by the uneducated masses.

The wolf as a supernatural creature prevailed from the beginning of recorded history to the sixteenth century. Superstitions of the Middle Ages may have given way to Renaissance enlightenment, but the European understanding of wolves would remain in the realm of the fantastic.

Perhaps some of the most unusual wolf folklore was accumulated by naturalist Edward Topsell. Educated at Cambridge, a minister in the Church of England, and an author, Topsell published several volumes of sermons, lectures, and animal histories in the early 1600s. Drawing from the speculations of previous naturalists who actually knew very little about the natural world, he presented the world with an "educated" and "moral" understanding of the wolf. Topsell's observations at the turn of the fourteenth century were, at best, fanciful folklore. He combined what was assumed as truth in nature with homeopathic medicine.

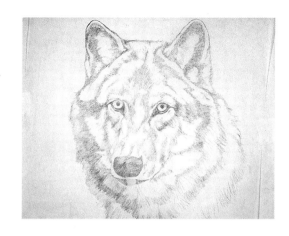

Alpha Male

Spirits Freed

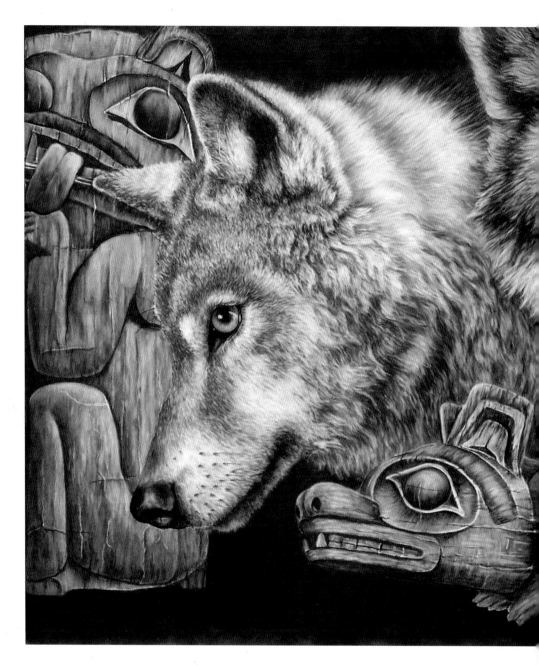

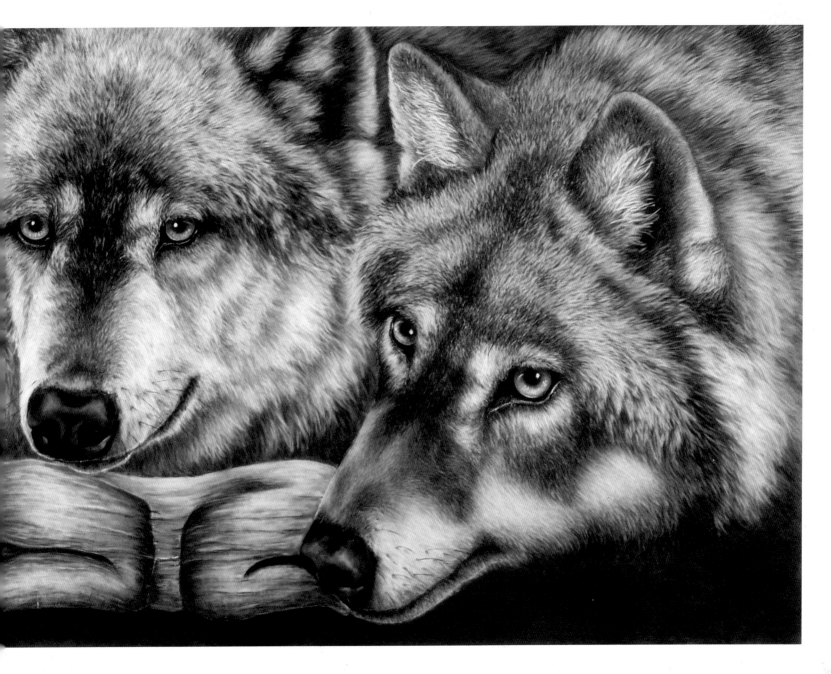

I had a dream which was not all a dream.

LORD BYRON

Watcher

According to Topsell and his research, a diversity of wolves inhabit the world, and he describes several. The first, *Sagittarius,* features legs designed to run fast and has a large head, which it wags constantly. The wolf's underside is spotted, and it has eyes that flame with fire.

Lyco harpages, the ravening wolves, Topsell describes as swifter than any other kind of wolf. The animal has a silver tail and resides in the mountains, venturing into towns during winter to kill livestock.

The golden wolf, *lupus aureus,* is the beauty of the wolf world. This wolf, having splendid fur the color of gold, is considered something more than a wolf, a unique creature. Possessing remarkably strong teeth, the golden wolf can bite through stone, brass, and iron.

A wolf-like beast called the sea wolf survives on fish and lives by the ocean. Thick hair protrudes out of either side of its eyes, and black spots dec-

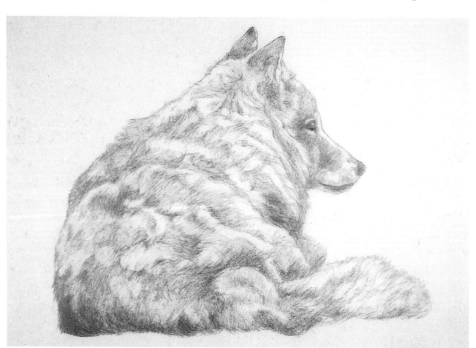

orate its sides. Its nose and teeth are similar to a dog's, and it has a long bushy tail.

Topsell attributes fantastic qualities to wolves. He reports that wolves' eyes radiate beams made of fire, and they can see better at night. Wolves possess an extraordinary sense of smell, and their brains swell with the waxing and waning of the moon. The neckbones of wolves are rigid, and the animals must turn completely around to look behind them.

When crossing water, wolves will grasp each other's tails with their mouths and form a line to cross a river. They will also do so to drag a large beast of prey from the water. They do not like to be watched as they eat. Before killing prey, wolves will consume a particular kind of earth to make themselves heavier and therefore more powerful when attacking and bringing down a large animal. Once the prey is dead, they will disgorge the dirt and feast. Wolves will always choose an animal over a human to kill and eat. When stalking goats, wolves carry small branches covered in leaves to entice the goats to come closer and forage. Once captured, a goat will be led by the ear to the wolf pack, driven forward as the wolf beats the creature with its tail, until the pack pounces upon it and devours all but the entrails. A wolf will attract a sheep with a noise made by its paw. Upon finding a flock of sheep, the wolf will kill the entire herd but eat only one sheep. When packs of wolves cannot find meat, they race around in a circle. The first wolf to become dizzy and collapse is eaten by the other wolves.

The wolf is said to fear fire, the noise of swords struck together, and the ringing of a bell. To make no sound as they travel, wolves lick the bottoms of their paws. If a wolf steps on a twig and breaks it, the animal will bite its own foot. If threatened by a hunter, the wolf will sever the end of its own tail with its teeth.

Topsell writes of remarkable uses for the parts of wolves:

Being anointed upon those whose joints are broken, the fat of a wolf does very much profit. Some of the later writers were

Night Scene

wont to mingle the fat of the wolf with other ointments for the disease of the gout. Some also do mingle it with other ointments for the palsy. The head of a wolf, being burned into ashes, is a special remedy for the looseness of the teeth. A wolf's right eye, being salted and bound to the body, drives away all agues and fevers. The right eye is very good against the biting of dogs.

The blood of a wolf being mixed with oil is very profitable against the deafness of the ears. The dung and blood of a wolf are much commended for those that are troubled with the colic and stone. A wolf's flesh being boiled and taken in meat helps those that are lunatic. A wolf's flesh being eaten is good for procreation of children.

The teeth of a wolf, being rubbed upon the gums of young infants, do open them, whereby the teeth may the easier come forth. The heart of a wolf, being burned and beaten to powder and so taken in drink, helps those that are sick of the falling sickness.

Primal Law

These and other myths were acceptable realities in a world full of unknowns. The masses, subjected to a religious and royal hierarchy, embraced the explanations that came down to them from the educated few. They transformed these concepts into a common vernacular, unaware of the harm that many of their beliefs would pass on to the New World. As colonists arrived in America, they brought new beliefs about nature which were inspired by the religious fervor developing during Topsell's era. Nature, branded a godless wasteland, held no advantages for the pure of heart or the ailing. Boiling wolf flesh or burning the heart of a wolf were considered activities of the possessed, and any Puritan caught or accused of such activities was burned at the stake. The wolf and its properties, whether fantastic myth or simple folklore, were deemed agents of the Devil.

The campaign to bring European civilization to the American frontier has its familiar tragedies. The subjugation of the Native American is perhaps its greatest crime. As this campaign progressed, the methodical slaughter of wolves and other predators increased as the roaming buffalo herds were exterminated and replaced with domestic cattle and sheep. A new mythology grew out of this battle to overpower the frontier, one that did not depend on spirits or sorcery or the influence of the gods. It was the embodiment of all things brutal and real in the wilderness—the unpredictability of nature, the constant loss of livelihood, the endless struggle to survive. It was a mythology populated by outlaws and bandits. The wolf—an elusive, unsettling predator—fell easily into this role and was quickly elevated to the status of a murderous renegade gone wild. In her book, *The Golden Hoof,* Winifred Kupper describes an attitude toward the wolf that survives in many parts of the country today:

> That the wolf bandit was looked upon as an individual is attested by the circumstance that after his first year of depredation he was usually awarded that symbol of respect, a name, and thereby distinguished as an inhabitant of the community and a part of its history. The name was always preceded by the adjective "old," pronounced *ole.* More often than not it told the story of an escape from a trap. For when a wolf is caught in a trap he will chew himself out of it and limp away, leaving a claw, foot, or leg. His telltale tracks, after such an amputation, serve to christen him Old Club Foot, Old Crip, Old Stubby, Old Two Toes, Old Three Toes. The name of Old Three Toes became the Smith or Jones of the lobo race. There was the Old Three Toes of Hall County, who forestalled capture for so long and murdered so many sheep that when he was finally caught he was stuffed and put in the First National Bank of Memphis, Texas. Nobody in Hall County wanted to forget him; he had given them too good a chase. He had a namesake in Montana, in Arkansas, in the Big Bend—all famous lobos.

Spear

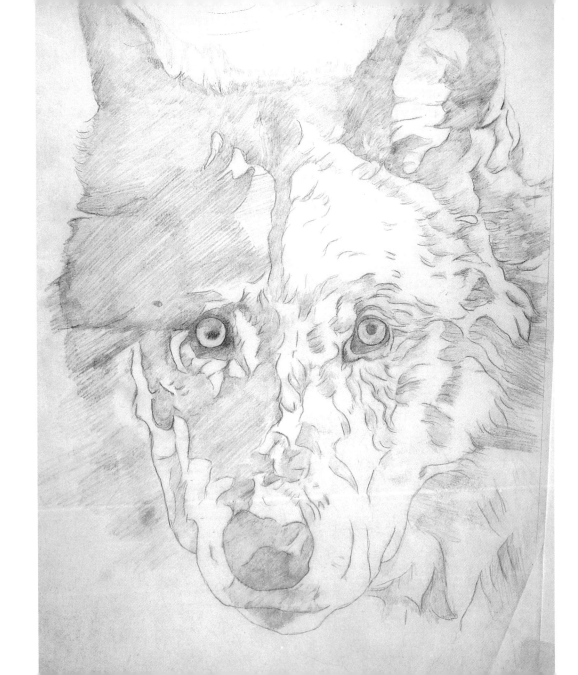

It takes in reality only one to make a quarrel. It is useless for the sheep to pass resolutions in favour of vegetarianism, while the wolf remains of a different opinion.

WILLIAM INGE
Outspoken Essays

Outlaw

42 ◆ 43

One of the most famous wolf stories in the frontier mythology, "Lobo of Currumpaw," was written by the naturalist, writer, and wildlife artist Ernest Thompson Seton. Seton was born in England in 1860 and at the age of six left with his family for Canada. He eventually lived in the southwest United States until his death in 1946. Traveling throughout the American and Canadian frontier, he sketched and painted the natural world and wrote books and stories about his observations and experiences.

Seton was especially fascinated with wolves. Wolves populated a great many of his stories and sketches. He even incorporated a wolf print into his signature. Seton's books and paintings gained significant popularity and were read and exhibited throughout the country. He was a frequent lecturer, and many of his talks, including a brief account of the Currumpaw wolf, advocated the importance of wolves and their place in the natural world. It was an awkward and unpopular position for a man who counted ranchers, hunters, and trappers as his friends. But the "Lobo of Currumpaw" marked a solemn conversion for Seton and an even greater turning point for the survival of the wolf:

"So, on January 4, 1894, I set out for the Currumpaw, taking over a hundred big steel traps, the wagon and team, and two helpers, Billy Allen and Charley Winn. On arrival, we prepared the old Currumpaw ranch house for a prolonged stay, and began a methodic exploration of the country.

"Very soon, I learned that the cowmen of the Currumpaw believed the wolf bands to be led by an immensely big strong wolf of supernatural cunning.

"My great problem was to get this notorious wolf, the 'Lobo of Currumpaw.' In my book, *Wild Animals I Have Known,* I give the story at length; but in my lectures I have adopted the briefer form, the one given here.

"To understand his nature, one must remember that a wolf is nothing but a big wild dog getting his living by his wits, his speed, and the strength of his jaws.

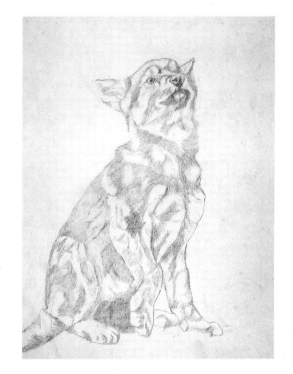

Wolf Pup

Six sample arrows showing different feathers

"If a wolf pup be taken very young, and brought up in the ranch, he behaves much like a dog. Some, at least, so taken, are perfectly kind and friendly.

"But Lobo, the big wolf of Currumpaw, was not brought up in this fashion. He brought himself up, not indoors, but out on the open range; and he was far from being as kind as a dog. He was a bad old cattle-killer. It was commonly said that he killed a cow every night, which may or may not be true. Of course, he did not need that much meat. But the belief was that his devilish cunning warned him never to return to his kill; it was too apt to be surrounded by traps and poison the day after the killing. Therefore, fresh beef every night was his rule. . . ."

Seton and his men pursued the wolf diligently but with little success. The wolf avoided their traps, left poisoned meat untouched, and rendered their guns useless with a simple but fail-safe tactic—he never allowed himself to be seen.

"I was at my wit's end now. I had been in pursuit of him, not two weeks, as I had expected, but four months; and I was no nearer to success than any other man. Yes, the old wolf might have been there yet, but that he made one terrible mistake. Oh! be warned by his blunder. He married a very young and very silly wife."

Old Lobo of Currumpaw had paired with a mate, a young wolf. Seton and his men called her Blanca. Seton managed to capture and kill Blanca and then use her severed paw to create a trail through the dust leading to a series of traps. It did not take long for his plan to work. Within days, Old Lobo was caught in the traps.

"Then I took down my lasso; and as I did so something like pity possessed me. I had been after him for four months, the other men for five years; and now, when I found him in my power, I began to feel sorry for him."

With assistance from his men, Seton roped the wolf and tied him up. Once he was secure, with a stick between his jaw and a heavy rope around his muzzle, Seton laid the wolf across his saddle. It was Seton's intention to

bring the wolf back to the ranch house alive.

"There was no wound on his body, his eye was bright and clear, he seemed in perfect health that night when I went in and left him. But we know that an eagle robbed of his freedom, a lion shorn of his strength, a dove bereft of his mate, all die—they say, of a broken heart. And who will claim that that wild robber wolf could bare the threefold brunt, heart-whole?

"This only I know: when the morning dawned, I stepped outdoors. He was lying just as I had left him, his head on his paws—his muzzle pointing down the canyon. But his spirit had flown—Old Lobo of the Currumpaw was dead.

"I took the chain and collar from his neck, the cowboy came to help me. As we raised his body, there came from the near mesa, the long and mournful howling of the wolves. It may have been the ordinary hunting cry; but, coming at that moment, as it did, it seemed to me a long, sad, faraway farewell.

"We carried the body into the outhouse, where lying still was the body of Blanca, his Blanca; and as we laid him down beside her, the cowboy said: 'There, you would come to her, so now you are together again.'"

Seton's penchant for drama and tragedy launched a vital change in the way Anglo-Americans viewed the natural world. His collection of stories, *Wild Animals I Have Known,* was read widely by the public and has been translated into every major European language, as well as Japanese, Hebrew, and Chinese, since its first publication in 1898. The emotions he imparted to the wolves and other animals in these stories enabled his readers to experience nature from a new and empathetic perspective. In the section called Note to the Reader, he shares his own ethical convictions:

"Such a collection of histories naturally suggests a common thought—a moral it would have been called in the last century. No doubt each different mind will find a moral to its taste, but I hope some will herein find emphasized a moral as old as Scripture—we and the beast are kin. Man has

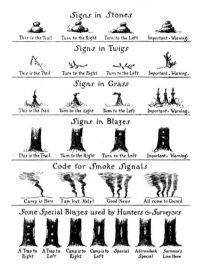

Indian signs

nothing that the animals have not at least a vestige of, the animals have nothing that man does not in some degree share.

"Since then, the animals are creatures with wants and feelings differing in degree only from our own, they surely have their rights."

Over a hundred years have passed since the death of Seton's wolf, and in that time America has awakened to a mythology of a new order. It is a mythology constructed out of realism and desperation—an objective, informed understanding of nature and a desperate struggle to salvage what is left of the natural world.

To live without myths would be to live without identities, a sense of place in the past and a promise of a future. The task of embracing a new mythology is one shared by all. But giving it voice and setting it loose to dwell within the human consciousness belongs, as always, to the storyteller.

In his novel *Wolf,* American writer Jim Harrison creates a mythology of self, a "false memoir" that mourns the transient nature of families, lovers, and dreams. It is a memoir of the author's own interior wilderness. The wolf, a presence never quite fully revealed, lingers at its edges:

> I have lost my faith I thought in "figuring things out," the various tongues in my skull that spoke daily of alternatives, counter-

Wosca

ploys, divisions, instructions, directions. All the interior sensuosi-
ties of language and style. And I live the life of an animal and
transmute my infancies, plural because I always repeat never con-
quer, a circle rather than a coil or spiral. I've talked myself into
the woods up here and will there be a common language when
I return? Or is there a need for one or was there ever such a lan-
guage in any world at any time? I think so. Before the gibbet or
guillotine the cheers take the same arc of sound and come from
a single huge throat. No king to require a spokesman. Off in the
dark there is a wolf who speaks his limited instincts to another. I
imagine he knows that there are few of his own kind left.

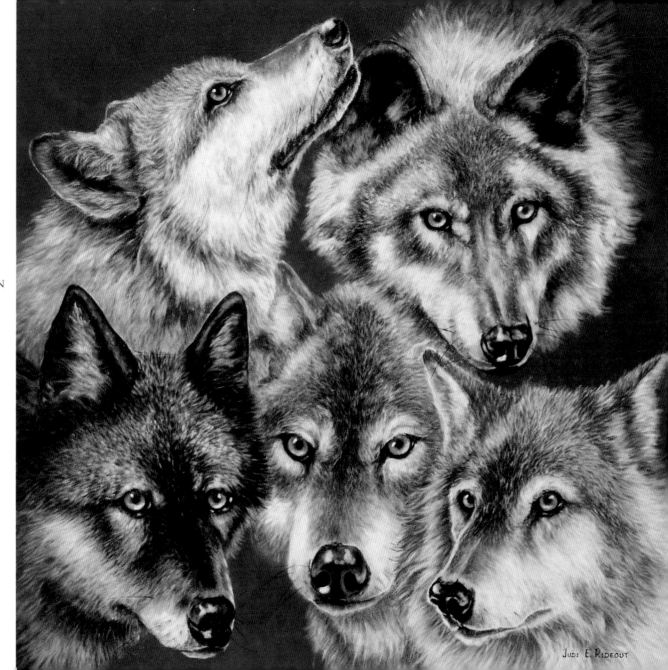

"Witch-hazel blossoms
in the fall,
To cure the chills and
Fayvers all."

ERNEST THOMPSON
SETON
The Sanger Witch

RIGHT
Within Sight II

JUDI E. RIDEOUT

III
DESCENT OF MAN
Wolf Extermination Campaigns in America

The colonists of New England concocted home grown remedies with the curious patter of alchemy, divining cures and deaths from the raw materials inhabiting the natural world. They brought many unusual folklore recipes from their homeland to help them start and survive a new life on the North American continent. The challenges they faced in the New World were many, and they required a steadfast faith in homemade prescriptions.

Nature provided a bounty of stock to fashion into necessities and occupy the creative hand. Wolf baits, poultices, healing teas, salves, insect repellents, amulets, seasonings, balms, ointments, charms, and tonics were foraged from the wilderness surrounding the colonial settlements of the seventeenth century. Herbs, flowers, roots, fungus, and the bark of trees were gathered for sedatives, restoratives, and embrocations. Fat was melted for soaps and candles. Berries were boiled down to dyes and hides were softened for gloves and pants, while the fur was tanned for winter coats. Logs were timbered and stones gathered for homes and furniture. Quills were plucked for writing in ink and reeds carved into flutes.

The colonists' resourcefulness was admirable. Drawing on their limited understanding of nature, driven by fortitude and a constant necessity to improvise, the colonists flourished in the natural world with the most rudimentary of skills and knowledge. Perhaps, had they continued to progress

toward a gracious coexistence with nature, the generations that followed would not have exacted such a devastating toll on the country's native environment.

But the colonists of the New World did not choose to develop a respectful cohabitation with the very resources that sustained their lives. Instead, they allowed their progress to be governed by a strict spiritual platform, one that left little room for an equitable relationship with nature. The colonists held firm in their belief that all things within the natural world existed specifically for their benefit or to their detriment. Nature was either to be exploited for survival and personal gain or destroyed if it seemed harmful or tempting.

The New World was a wilderness without God, inhabited by savage and dangerous creatures. To the colonists, salvation through domination, control, and redemption was the only hope of creating a livable, righteous place. The colonists applied themselves to this pursuit with a naive and puritanical religious fervor, creating a spiritual arsenal designed to guide them through the rigors of nature—one that would forever alter the face of the American frontier.

Every human drama dominated by religious zeal demands a simplistic hierarchy that dictates what is good and what is unredeemably evil. Fear is the force propelling the characters forward, and to see the drama through, evil must manifest in a physical form. For the colonists of New England, the wolf became the most frightening incarnation of evil, suffering, and death.

The persecution of wolves by the New World inhabitants did not begin until the introduction of livestock. In 1609, Jamestown, Virginia received a shipment of horses, cattle, and swine, and within twenty years, raising stock became a common practice. Sheep and cattle, defenseless by nature, were easy prey for the wolves roaming the unsettled regions of the colonies. Losses were to be expected when raising livestock, and in all probability, the toll taken by disease and other misfortunes was far greater than losses to predation. But along with a penchant for husbandry, the colonists

had crossed the ocean bearing folk tales and superstitions about the natural world. Wolves featured prominently in this mythology, appearing as were-wolves, the Devil's disciples, and denizens of the unknown wilderness. The Church, taking advantage of the wolf's unpopular status, unified its congregation in opposition to this tangible force.

Puritan preaching, charged with denouncing the wilderness as a heathen sanctuary, judged the wolf the representation of all things pagan and treacherous to the soul. Wolves dominated the dangerous wild interior of their country, howled through the colonists' fitful slumber beneath the pagan moon, and occasionally ate a lamb of God. The wolf of the seventeenth century became the Devil and embodied all the sins a colonist was tempted to commit. By destroying the wolf, followers of the righteous believed they were, in effect, eliminating the evil within. The act carried no moral judgment, as animals had no spirits, no souls, and were put on earth for humans to nurture for sustenance or destroy as a demonstration of spiritual conviction.

Typically for the period, religion became law. By 1630, the Massachusetts Bay Colony began offering cash rewards for killing wolves. The colonial government placed an assessment on each head of livestock, collecting money from colonists to pay for the rewards or bounties. These rewards were paid to anyone who brought in a dead wolf, with Native Americans receiving a smaller amount of cash than did Englishmen. Bounties were also paid in bushels of corn, quarts of wine, powder and shot for firearms, pounds of tobacco, or trading cloth.

Other colonies followed with their own wolf bounty laws. Virginia required that local Native American tribes turn in an annual quota of wolf hides. Manhattan Island, a Dutch colony, paid bounties in gold coins. Towns in Massachusetts were ordered to set and bait a specified number of wolf traps and were fined if their citizens neglected to do so.

Laws regarding the killing of wolves and bounty payments were constantly revised and expanded. The Colony of Massachusetts Bay Wolf

Captive

Legislation of 1648 specified that any Englishman or Native American killing a wolf within the colony's jurisdiction must bring the head of the wolf to the constable. The constable would then bury the head and pay a cash bounty out of the public treasury.

By the mid-seventeenth century, many colonies were hiring men to hunt wolves professionally. A salary was provided and often a bonus was paid for each wolf killed. Female wolves brought a greater cash reward than male wolves. The Colony of Pennsylvania, in an attempt to avoid the fraudulent practice of collecting rewards repeatedly with the same wolf head, required the constable to cut off the ears and cut out the tongue of each wolf presented for bounty payment.

In an era of fierce independence, the killing of wolves became a galvanizing force for both the New World church and its government. Unification of the citizens was necessary for the success of both institutions. Fear of the wolf and its wilderness provided the basis for the spread of religious propaganda. The government's sanctioning of retribution against the

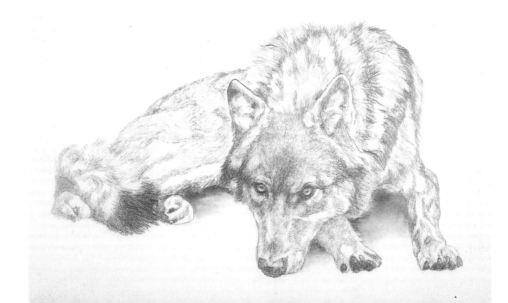

wolf solidified the church's position with a physical—and lucrative—occupation.

This hatred for the wolf and all things wild incubated in a society where fear grew into obsession, obsession inspired hysteria, and hysteria motivated acts of violence and destruction. It was a bitter and ignorant fire that drew in more than just the wolf. The colonists would eventually turn on their own neighbors and families, accusing them of the same irrational satanic alliances. The "guilty" were burned at the stake, submitted to cruel tortures, and stoned to death.

This insanity finally subsided by the mid-1700s, but efforts to exterminate the wolf in New England continued. By the end of the century, the wolf would begin to disappear completely from the American Northeast. It was an unnecessary massacre, justified by an ignorance that would spread throughout the American frontier and instigate the largest slaughter of wolves in the history of the world. Rather than prove the wolf a devil, this campaign would ultimately reveal the sordid spirit that dwells—not in the natural world—but within human nature.

Our manifest destiny is to overspread the continent allotted by Providence for the free development of our yearly multiplying millions.
JOHN LOUIS O'SULLIVAN

Expansion was the life force of nineteenth century America, and the West became its future. Between 1815 and 1850, Americans began to populate the land west of the Appalachian Mountains. The population grew almost three times as quickly as had the original states of the New World. In the early 1840s, Americans pushed more than a thousand miles westward, across the Great Plains and over mountain ranges, driving wagons, horses, livestock, and families along the Oregon Trail.

Wolves, buffalo, and Native Americans were perceived as detriments to this migration and their mass extermination became policy. Church and

government coalesced with the creation of an official expansionist doctrine—"manifest destiny." The doctrine promoted the belief that the United States was destined to expand its territory and encompass all of North America, extending and enhancing its political, social, religious, and economic influences. That this meant control over the existing native system through subjugation and massacre was incidental, as man had moral superiority over all things inhabiting the frontier.

Until Charles Darwin published *The Descent of Man,* Americans understood very little of biology and the relationships inherent in nature. Science presented a frightening and unfamiliar definition of the universe, one that opposed the tenets of the Church and its Puritan ministers. But secular beliefs began to proliferate despite opposition. New ways of exploring human origins and an understanding of natural order were ultimately embraced by American society. But rather than rescue the wolf from certain doom, science would become a primary factor in pushing the animal to the brink of extinction in North America.

In "Trail of an Artist-Naturalist," Ernest Thompson Seton explores this theme:

> . . . It was a cold wet night in late November, frost in the air, wet snow everywhere, when Natty Lincoln rode in about ten o'clock. He was nearly frozen. The resident boys were in bed.
>
> Nat turned his horse loose, and walked in.
>
> "Say, Jack," he called, "have you any quinine? I'm all in."
>
> "Sure," said Jack. "On the shelf back of the stove."
>
> Yes, there it was in the dim light—a fat little bottle, the familiar ounce container of the quinine.
>
> Nat took a dipper of water, and swallowed a spoonful of the quinine.
>
> "Gosh," he exclaimed, "that's the bitterest quinine I ever tasted."

Then he fell on the ground, writhing and screaming in agony.

The other boys jumped out of their beds in sudden terror. "What is it? What's up?"

"Jack, Jack, if ever in my life I done you a kindness, for God's sake, take your gun and kill me! I got the wrong bottle; I got the wolf poison."

Shrieking in agony, poor Nat went down again; and in three more minutes was dead.

I was not in that ranch house at the time, but I was in the neighborhood, and got the story firsthand from those who were there. It affected me deeply. What right, I asked, has man to inflict such horrible agony on fellow beings, merely because they do a little damage to his material interests? It is not right; it is horrible—horrible—hellish!

And I put out no more poison baits.

Wolves were slaughtered at the hands of many people as Americans moved west—stockmen, the military, farmers, railroad laborers, cowboys, and constables. But wolf killing as a profession belonged exclusively to the trapper.

Trappers were entrepreneurial by profession and reclusive by nature. A trapper would typically spend months at a time in the wilderness, alone or with an occasional partner, tracking, baiting, trapping, killing, and skinning fur-bearing animals. His survival skills and knowledge of the natural world were rivaled only by Native Americans and the animals he trapped, which at times he would be pressed to admire as well as abhor.

Early trappers were content to occupy their time in the lucrative beaver trade. The pelt fur, thick and luxurious, was in high demand, made popular by the clothing styles of the day. As a result, trappers decimated the beaver population in New England and began to move west in search of

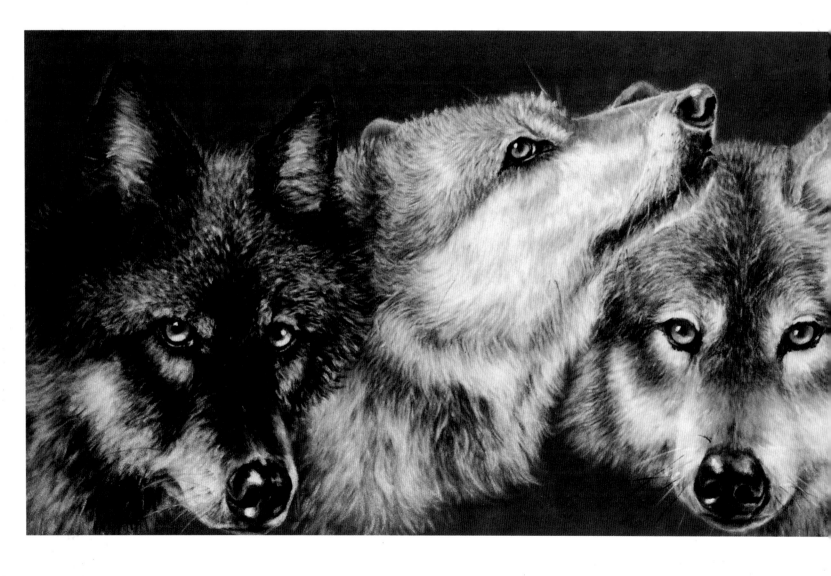

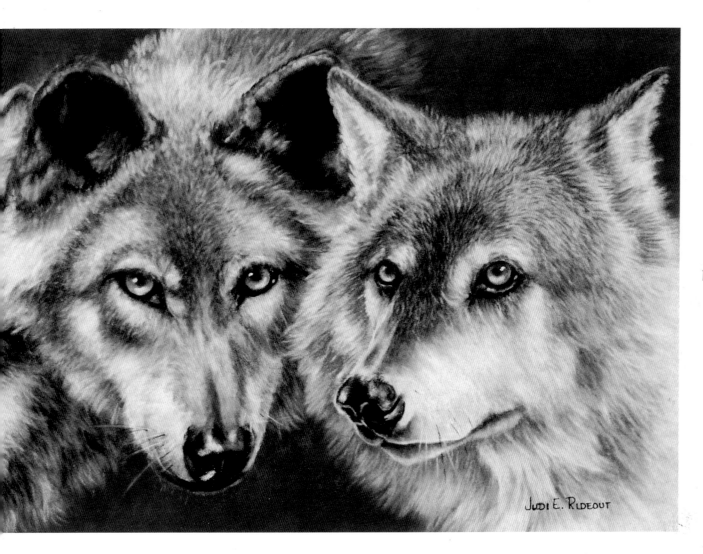

Wolf Mug Shot

JUDI E. RIDEOUT

more pelts. By 1850, the beaver was near extinction, and with the changing trends in men's fashions, the beaver fur industry collapsed.

However, the trapper's misfortune was short-lived. The value of wolf pelts increased substantially with their growing popularity as overcoats and robes. In addition, ranching began to dominate the land as Americans moved westward. Ranchers and pioneers branded the wolf an evil, scavenging coward, and the western states began to pass bounty laws. Trappers were the ideal candidates to carry them out. States set up programs to levy assessments on livestock, much as the colonial governments did, and pay out bounty rewards through the treasury. Between 1875 and 1893, bounties increased from fifty cents to eight dollars per wolf. Stockman associations and individual ranchers began offering their own rewards for any wolves killed on their land. Trapping was once again a lucrative profession, often providing three separate bounty payments on a single wolf—one from the county government, one from the state, and one from the local stockman's association.

The methods used by trappers to catch and kill wolves bordered on the medieval. Pits, deadfalls, fishhooks, lassoing, hunts with dogs, hamstringing, and clubs were all part of the trapper's arsenal. Snares, made of wire looped into a noose and designed to slide closed, were hung along trails frequented by wolves. Once caught with the loop around its neck, the wolf would strangle itself in an attempt to escape.

Steel traps were designed with metal jaws that snapped together when a wolf tripped the spring-loaded device. The trap was typically buried lightly beneath the ground and secured to a rock or tree trunk by wire or a length of chain. Once sprung, the jaws would sever a paw or hold firm to the leg until the wolf died or was killed by the trapper.

Trappers took pride in creating scents to lure wolves into traps and it was rare that a trapper would divulge his special alchemy. Wolf entrails, brains, eyeballs, tongue, and even the pads of the paws were used to concoct a formula. The parts were mixed with warm water and allowed to sit

in a loosely sealed container and rot for a specified number of days. Dissolved wolf dung, urine, and glands of other animals, including skunk, muskrat, or beaver, were then added to the fetid mixture. The resulting brew was parceled out, a drop at a time, around the trap. Trappers would swear by their own special success in trapping the wolf.

Denning was a particularly cruel technique used by trappers. The trapper would crawl into a den with a pistol and a lit candle. When he could see the flame reflected in the eyes of the female wolf, he would shoot. The wolf pups were either carried out or fished out with a metal hook attached to a long pole. Those that did not die by the gaff were clubbed to death.

But poisoning, above all else, was perhaps the most damaging and indiscriminate technique used to kill wolves. Trappers favored strychnine, a colorless, crystalline poison originally extracted from the seeds of the *nux vomica*, an East Indian tree bearing orange-like fruits. Strychnine was cheap and available in crystals that dissolved easily. It was an effective killer and took less time to prepare than other techniques.

The application of strychnine was simple. The trapper would shoot a buffalo, elk, or other large animal, carve out chunks of flesh, cut slits in the chunks, and insert a dose of strychnine. The chunks were then scattered around the carcass. Additional cuts were made in the carcass and strychnine was applied to them as well. The trapper would return the next day to find as many as thirty or forty dead wolves. He would set to work skinning them, or in winter, he would gather the frozen carcasses and transport them back to camp. The carcasses were stacked up like firewood until the spring thaw allowed them to be skinned.

Other winter poisoning techniques were even simpler. Several buffalo were shot and cut open. The blood and intestines would be saturated with large quantities of dissolved strychnine as the viscera flowed upon the ground. Since the carcass would likely freeze before the wolves came upon it, the bloodied snow served as their first meal. The wolves would be dead within an hour of eating it.

Wolf Heads

Rather than dying quickly, some wolves became sick after eating the poisoned meat of a carcass. These wolves, unable to function, would wander off, disgorging poisoned bile and eventually dying in a slobbering fit. The slobber would contaminate the grass and cause the death of other animals as they grazed on the toxic plants.

The number of animals killed and used for poisoning wolves remains unknown. The wasteful slaughter of buffalo, antelope, and deer was justified by the unquestioned necessity of exterminating the wolf. But it was the indiscriminate nature of the poison itself that exacted the greatest toll on American wildlife. Millions of animals that fed upon the toxic carcasses were killed, including golden eagles, bald eagles, black bears, grizzly bears, coatimundis, ringtails, martens, minks, ermine, ravens, hawks, raccoons, skunks, red foxes, gray foxes, vultures, ferrets, badgers, coyotes, mountain lions, jaguars, ocelots, bobcats, and wolverines. The slaughter reached a plateau in the late 1800s with the scattering of strychnine-laced meat across the American plains. Many trails of poison extended over one hundred miles long.

But some trappers refused to use poison. For Ben Corbin, wolf trapper and author of *Corbin's Advice; or the Wolf Hunter's Guide*, published in 1900, this would be his only redeeming quality. Upon discovering a den of

wolf pups, Corbin would attach spring-loaded hooks to wires and then fasten the wires to a long steel line. Securing the steel line to a stake in the ground, he would bury it around the den, leaving the spring hooks exposed. Using chunks of chicken, Corbin would bait the hooks and leave. When the pups left the den at night, they would immediately find the chicken chunks and bolt them down whole. The spring hooks would snap, lodging in the pups' stomachs or throats. Corbin would return to the den the next day and club the pups over the head, cutting off their scalps for bounty rewards.

By 1900 the bounty system was an intrinsic part of the American heritage. Like many other trappers, Corbin believed that all wolves must be exterminated. Yet, to assure a steady income, he would kill wolf pups but leave the breeding pair to create new stock. Some trappers left certain dens unharmed to secure the next year's bounty, as bounties on adult wolves paid better than on pups. Parts of other animals, including foxes, bobcats, and dogs, were turned in for bounty collection. Pelts were circulated from state to state and scalps were used again and again. Road kills and accidental kills were turned in as well.

Several state legislators voiced their concerns about the mounting debit paid yearly to bounty hunters and saw the process as rural welfare. But other government representatives saw the bounty system as a political plat-

Wolf Cubs for Bounty

OVER
Bonded

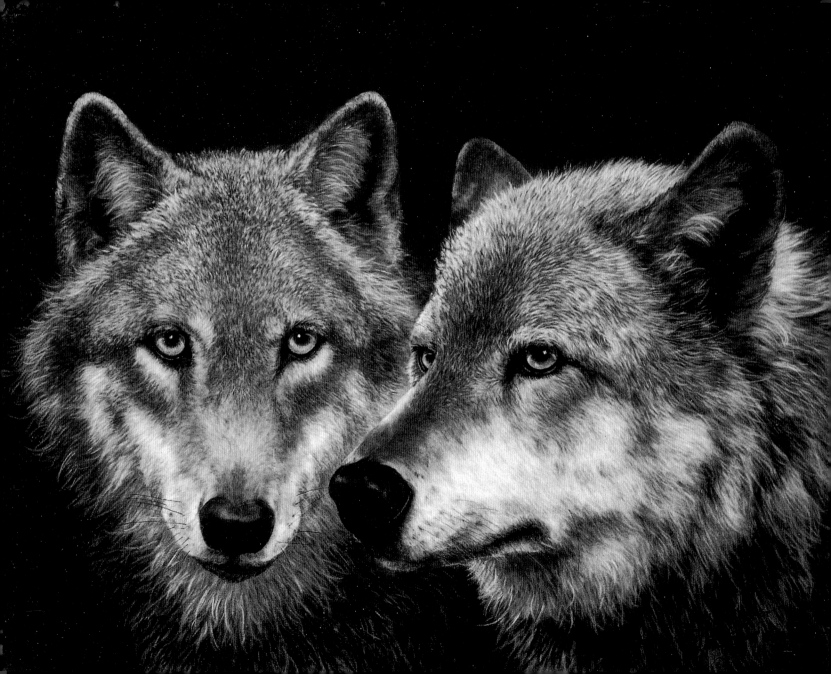

form. Bounties provided supplementary income to voters living in remote regions. Supporting bounty legislation drew the votes and loyalties of the ranching community, a growing economic influence in the American West. As a result, by 1914, the western states were pouring over a million dollars a year into bounty rewards.

It is but to paint a vast country of green fields, where the men are all red—where meat is the staff of life—where no laws, but those of honor, are known—where the oak and pine give way to the cotton wood and peccan—where the buffalo ranges, the elk, mountain-sheep, and the fleet-bounding antelope—where the magpie and chattering paroquettes supply the place of the red-breast and the blue-bird— where the wolves are white, and bears grizzly—where pheasants are hens of the prairie and frogs have horns!—where the rivers are yellow, and white men are turned savages in looks. Through the whole of this strange country the dogs are all wolves—women all slaves—men all lords. The sun and the rats alone (of all the list of old acquaintances) could be recognized in this country of strange metamorphose.

GEORGE CATLIN

The wolf's prairie domain was perhaps one of the most beautiful native environments in all of North America. But with the settling of the West, that which had taken thousands of years to evolve disappeared in less than a century.

By the late 1800s, the wolf's natural prey had been thoroughly decimated across the American grassland range. Bison, antelope, and deer were destroyed in a massive slaughter designed to drive Native Americans from the rich grazing lands. Early stockmen began herding cattle into wolf country, and the wolf responded by occasionally killing and eating the livestock.

The wolf became a scapegoat for all the ills that befell the ranching industry during this period of American enterprise. By 1890 the Southwestern frontier was covered in livestock as sheep were introduced along with cattle. The sheep's penchant for cropping plants down to the roots escalated the loss of native grasses. This overgrazing ultimately destroyed the vast prairies of the frontier and reduced much of the Southwestern grazing land to little more than scrubby desert. The years of 1891 and 1892 saw summer drought conditions that debilitated the return of perennial grasses. In 1893, overgrazing and drought brought about the loss of almost seventy-five percent of the cattle in Arizona. Within the year, the livestock industry crashed. Hundreds of dying cattle provided a bounty of prey for the wolf. The sight of wolves feeding on their lost livelihood and the constant threat of bankruptcy and land confiscation led ranchers to rally around wolf extermination efforts. But despite their ultimate success in eliminating the wolf in the American Southwest, ranching continued to be a lean and uncertain industry well into the 1900s.

During the early 1880s, in the Northwestern territories, cattlemen earned high profits from a strong beef market. Eastern investors supplied a steady flow of money to stockmen, and a healthy bounty system kept trappers employed. By 1886 the wolf population dwindled significantly. Two years of particularly harsh winters devastated the cattle herds. Investors' money, along with the privilege of free grazing on public lands, disappeared. The Montana legislature repealed its wolf bounty program. Too much money was being spent on too few wolves. In protest, Montana ranchers began a campaign to reinstate the bounty program, exaggerating livestock and dollar losses from wolf predation to justify their claims.

The extermination of the wolf once again became an obsession. By the early 1900s, stockmen were demanding that the federal government implement a program to eliminate wolves, not only from their ranch land but from the millions of acres held in reserve as federal lands. Over two hundred and twenty-five million acres were retained by the federal govern-

ment as national forests, national parks, game preserves, national monu-
ments, power sites, water reservoir sites, Native American lands, and oil,
phosphate, potash, and coal withdrawals. Represented by their lobbyists in
government, stockmen claimed that as long as wolves were allowed to live
and breed on these federal lands, their livestock and livelihood would con-
tinue to suffer. It was an unsubstantiated claim bolstered by suspicious and
unreasonable statistics. But the voice of the stockmen generated an
extremely powerful influence. The extent of this power became evident
when, in 1915, the federal government found itself officially in the business
of killing wolves.

> The mad mob does not ask how it could be better, only that it
> be different. And when it then becomes worse, it must change
> again. Thus they get bees for flies, and at last hornets for bees.

MARTIN LUTHER

In 1915 Congress approved $280,000 for the United States Biological
Survey budget. The USBS was one of several government agencies designed
to study and manage federal lands. Congress stipulated that $125,000 of this
budget must be spent on the destruction of wolves, coyotes, and any other
animals deemed detrimental to agriculture and the raising of livestock.
During the Senate debate to establish the final budget amount, very little
consideration was given to the actual necessity for a predator reduction pro-
gram. Many senators were unfamiliar with public land regulations and based
their arguments on incorrect assumptions. The fear that excess appropria-
tions would create a large bureaucracy was dismissed. But a bureaucracy was
exactly what resulted, and it was charged with eradicating the wolf from two
hundred and twenty-five million acres.

Under the USBS wolf extermination program, many trappers found
full-time work as civil servants. They were joined by employees of the

National Park Service and the U.S. Forest Service in their efforts to eradicate wolves from public lands. Despite its own reports labeling the wolf in New Mexico a minor problem, the USBS neglected to end extermination programs in the southwest. By 1925, native wolves were no longer a major predator in the region. But efforts continued, citing problems with rogue wolves, "illegal aliens" crossing over the border from Mexico. A wolf-proof fence constructed along the U.S.-Mexico border was a real consideration until the introduction of a new and deadly poison.

Poisoning was one of several wolf-killing methods recommended and utilized by the federal government, in addition to hunting down wolves with dogs and horses, killing the young in dens, trapping and shooting. Strychnine, encapsulated in a gelatin shell and inserted into bait, was known to dissolve in the mouth or stomach of a wolf within minutes. The poison would kill the animal in a very short period of time unless the wolf had eaten before ingesting the capsule. The animal would feel the effects almost immediately, then die five or six minutes later. The USBS determined this correct dosage through their experiments on dogs.

Cyanide devices were also used in the extermination campaign. The mechanical device was buried along wolf trails or near dens with the baited, explosive end sticking above the ground. As the wolf began to chew on the bait, a trigger blew sodium cyanide into its mouth, inducing a coma followed by death.

USBS trappers scented traps with the wolf's own urine. Male wolves were captured and wire was wrapped around their penises. The captives would eventually be killed and their full bladders removed. The urine was collected and applied around trapping sites.

By 1940, the USBS was integrated into the U.S. Fish and Wildlife Service. Research into a more efficient formula for poisoning wolves resulted in Compound 1080, which was tested in a southwest extermination pro-

gram. In preparation of its use, a device called a Morton Meat Gun was loaded with Compound 1080. A horse or mule was shot, and as it died, the gun injected poison into the muscle tissue. Blood flow carried the compound throughout the body, making the entire animal lethal to wolves and other canines. The carcass was butchered and the pieces anchored along known wolf trails.

The compound was utilized by both the U.S. government and by the northern governments of Mexico through a U.S.-backed wolf extermina-

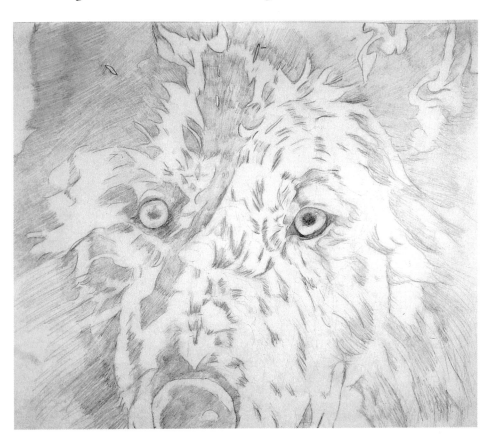

Last Encounter

tion program. It was an extraordinarily effective campaign; by 1958, the wolf had disappeared completely from the American Southwest.

Wolf populations in the federal lands of the northwest, subjected to the same treatment, declined rapidly. Yellowstone National Park, created in 1872, came under relentless predator extermination campaigns practically from its inception. The U.S. Army managed the park from 1886 to 1918. All scouts and noncommissioned officers had orders to kill any predator, including wolves. Yellowstone was handed over to the National Park Service in 1918, but the predator control program continued. In addition, the importance of game animals increased as hunting, allowed on public lands, evolved into a national sport. National Park Service managers categorized the wildlife inhabiting Yellowstone as "good" animals—large game animals such as deer and elk, which were natural prey for the wolf—or "bad" animals. Policy designated the wolf as a bad animal and called for the animal's elimination. Despite the service's admission that a healthy population of game existed in Yellowstone, the coexistence of wolves and game was unacceptable. Due to rigorous extermination efforts, the presence of wolves in Yellowstone diminished through the early 1900s to rare and occasional sightings. Although the service continued its predator control program by killing coyotes, bobcats, and mountain lions, the last two wolves taken through the program died in 1926.

The decline of the wolf population in Yellowstone reflects the fate of the animal elsewhere throughout the following years. The predator extermination programs were extremely successful and, with the exception of Alaska and a surviving population in the northern Minnesota wilderness, the wolf was virtually eliminated in America. By the time critics of the extermination programs began to speak up, the damage had already been done.

In nature there are no rewards or punishments; there are consequences.

HORACE ANNESLEY VACHELL

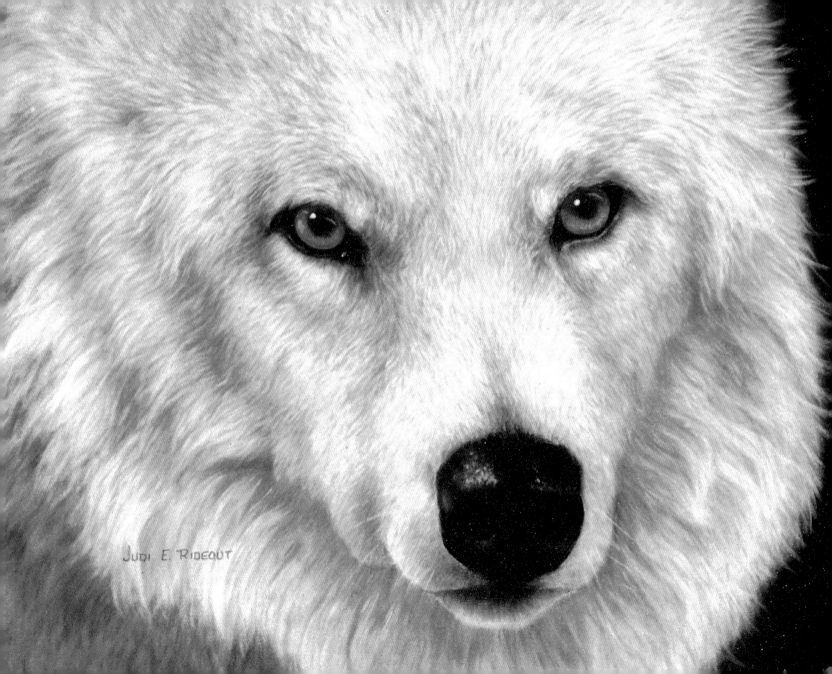

Judi E. Rideout

Individuals who were independent of government agencies and special interest groups began to question eradication operations as early as the 1920s. Biologists, particularly members of the American Society of Mammalogists, would claim what was already widely understood but ignored; that poison was an indiscriminate killer of wildlife. They supported the concept that all animals were of equal value in a natural environment, each playing a significant role in the healthy existence of a balanced community.

Criticism of government practices grew louder by 1930. Scientists admonished the USBS for steadily filling the positions of its higher offices with non-biologists. The survey was accused of catering to the needs of stockmen and game enthusiasts rather than fulfilling its purpose as steward of the public wilderness. Members of the American Society of Mammalogists took it upon themselves to travel throughout the western states without pay to review survey methods. Their conclusions, published in 1931, disclosed many disparities in the survey's policies and actions. The survey's indiscriminate destruction of wildlife, predation statistics based on hearsay, and distribution of propaganda to create additional demands for predator control were among the charges. The findings of the biologists were instrumental in revising the national policy on wolves.

By 1936, major changes occurred in the National Park Service. The concept of predators serving a vital role in the integrity of a healthy environment was accepted as scientific fact. For the first time in America's three-hundred-year war on wolves, the government utilized a rational approach to the animal, placing the wolf under the service's protectionist regulations. Recognizing the relationship between predator and prey as a basic function of natural order, the service established wolf sanctuaries in America's national parks. Unfortunately, no wolves were left to protect.

The environmental movements of the 1960s and 1970s propelled the plight of the wolf and other endangered species into the nation's consciousness. The 1972 banning of the use of predator poisons, including cyanide,

strychnine, and the deadly Compound 1080, on all federal and private lands ushered in a new era of environmental awareness. But it was the passage of the Endangered Species Act in 1973 that empowered the battle to save the wolf. The act charged the government with the responsibility of using its authority to conserve any and all threatened and endangered species and their natural habitat. Just as the wolf received special attention in the extermination policies of the 1915 Congress, a special program, called the Northern Rocky Mountain Wolf Recovery Plan, was created by the U.S. Fish and Wildlife Service to fulfill the legal mandate of the ESA. The plan was introduced in 1987 and designed to establish wolves in three original ranges of northwestern America. A minimum of ten breeding pairs apiece would be introduced to northwestern Montana, the central wilds of Idaho, and the matriarch of the American wilderness—Yellowstone National Park.

Despite efforts to save the wolf, it is now more difficult to imagine a world with wolves than one without them. For Americans who have ventured into the nation's wild places, the howl of the wolf has not been heard regularly for over seventy-five years.

Almost 150 years ago, Henry David Thoreau wrote about the tragedy of such losses on the human consciousness. "Primitive Nature is the most interesting to me," he wrote. "I take infinite pains to know all the phenomena of the spring, for instance, thinking that I have here the entire poem, and then, to my chagrin, I hear that it is but an imperfect copy that I possess and have read, that my ancestors have torn out many of the first leaves and the grandest passages, and mutilated it in many places. I should not like to think that some demigod had come before me and picked out some of the best of the stars. I wish to know an entire heaven and entire earth."

In wildness is the preservation
of the world.

HENRY DAVID THOREAU

All passes. Art alone
Enduring stays to us;
The bust outlasts the throne—
The coin, Tiberius.

HENRY AUSTIN DOBSON

Too Close to Pause

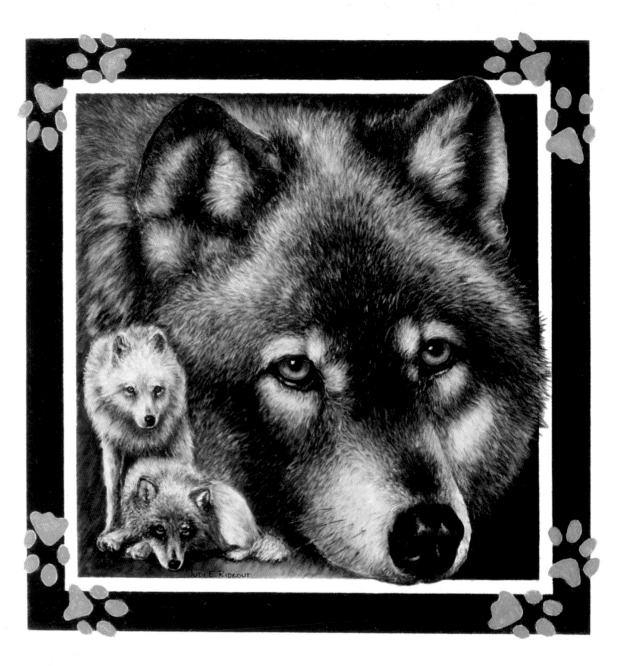

IV
IN THE COMPANY OF WOLVES

The Artist and the Eyes of the Wolf

A work of art often assumes a much greater role than simply perpetuating the legacy of its creator. Sometimes it endures as a final testimony to things lost or let go—Audubon's illustrations of species long extinct, Catlin's painstaking renderings of Native Americans in ceremonial dress, and Bierstadt's panorama of a nineteenth-century American sunrise, the light veiled in fogs and mists and the earth's untainted transpiration. All portray the last remnants of an unrecoverable past.

Art captures something that science and folklore and politics cannot— a vision of the subject rendered that transcends the need for statistics and charts, arguments and policies. Science discloses logic, politics beget power, industry creates money, and religion acknowledges convictions. But art responds to the soul of things. It is perhaps this internal connection that permits artists the clearest vision of nature.

"I try to capture the spirit of the wolf. It is, to me, a spirit freed." Judi Rideout sits in her studio, looking south through a window at Pioneer Peak. Her house, built by Judi and her husband Ken, is shrouded in its shadow. "I often feel that I didn't really choose to start painting the wolf. Rather, it chose me. I'm not really sure what made me begin. Maybe it was the fur.

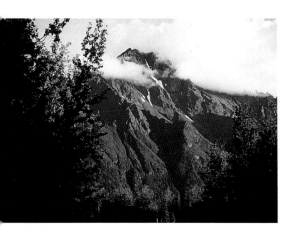

The view from Judi Rideout's window

The eyes. They just happened. They found me. When I work on a painting, sometimes the wolves speak to me and sometimes they don't. And sometimes they talk and will not be silent until the painting is complete."

Her house is surrounded by the mountains of Alaska—the Chugach range to the east and south and the Talkeetna range to the north. Wolves are known to inhabit the Talkeetnas. Their tracks cross the winter snow at a distance much closer to Judi's house than the nearest mountain of ice. Just twenty miles away, the Knik Glacier melts imperceptibly in the July heat.

"Summer is very green and lush here. The flats are full of lupines and wild iris. But my favorite is the fireweed," says Judi. "The show begins in midsummer as the tall spikes bloom magenta from the bottom up. The leaves turn fiery red in the fall, and the mountainside looks as if it were ablaze. Then, as the tops of the spikes flower out, the lower blooms blow cotton-like seeds, telling me that winter is closing in. I call it my wintervane.

"Lazy Mountain is just out my north window, and old timers say that it takes three snows on the peak for winter to arrive. I've watched it over the past twenty years. They're right. But you can never actually see it snow on the top of the peak. Clouds float over it and sit for a while, cascading flakes down the mountainside. Then the clouds move on and the sun comes out, turning the peak a brilliant white. By the third snow, winter has created a gray and white world. But every once in a while, when the sun breaks through, the mountains take on colors I have never seen before—strange hues of blues and pinks and lavenders. Then sometimes the snow-covered peaks turn to gold.

"I love the change of seasons in the mountains, like the changing of emotions. The sun will shine day after day, and the cold will just go away and leave only beauty. Then one evening, I will fall asleep to the wind blowing over the tops of the spruce, the ice will crack and wake me in the middle of the night, and I will know in the morning that everything has thawed and melted into spring.

"This country I live in is rough and unforgiving, majestic and beautiful and, on those days when the wind is relentless, it is a bitter, bitter cold

wilderness. But as it weaves all those things together, they become the spell that holds me here and makes me stay—a perfect place, every day and every frozen night, for all things wild and free."

Judi and Ken always knew they were destined to live in a wild place. As childhood sweethearts in northern Minnesota, they grew up enjoying the outdoors. They nurtured and shared the desire for a different and challenging kind of lifestyle, one that featured nature as a primary component.

"When we were growing up, every so often someone from another part of the country—an artist or naturalist—would come through town and show a movie and give a presentation about their lives, what they did and where they lived. Whenever there was one about Alaska by someone living the rough life of the outdoors, Ken and I went. It was as if we were drawn to them like bits of iron to a magnet.

"We married fresh out of high school and put together a plan. Four kids and a life in Alaska. That was our goal. We got married so young, just two dumb kids. After a couple of children, we realized that was plenty. So part of the plan was accomplished. But there was still Alaska.

"It took us fifteen years to achieve. Ken, a meat cutter, was working in a grocery store. Once the kids started school, I took a job at J. C. Penney's. Ken came home from work one evening and said he was going to Alaska on vacation. I told him that he wasn't going without me, so we each took a month off of work, planned out our itinerary, packed up, and got on the road. That was in August of 1973.

"Ken's father Clint was working as a surveyor for the state. When we arrived in Alaska, Clint toured us around and took Ken hunting while I drove the kids down to Seward to watch beluga whales, puffins, and sea otters. When we met up again, Ken and I really didn't talk much about moving. We just looked at each other and said, 'This is it.' Clint helped us find some property, we put some money down, went home, called our families the night we returned, and told them we were moving to Alaska. Then we sold everything we had, and left.

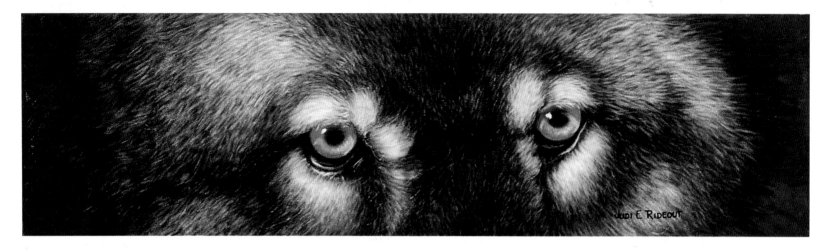

Eye to Eye

"It gave me a profound sense of freedom that I had never felt before. I believe there are moments in one's life when the opportunity to live freely makes itself known. It's a transitory moment, one that can slip through your fingers if you let it. I guess that's what I admire most about wolves. They lead a marvelous life, free to wander and make the best of what they can find. And wolves, like those moments, sometimes appear unexpectedly.

"I remember the first time I saw a wolf in the wild. I always thought that I would see one while Ken and I were hiking or hunting or rafting down an Alaskan river. We always saw tracks in the snow or along the mud of the bank. Instead, it was early one morning as I drove along a back road on my way to the Anchorage highway. It was February. There's a slough that runs across the middle of the road, and in the summertime it's wet and soggy and full of swans. But it had glazed over and frozen solid by this time of the year. I saw the wolf standing at the edge of the ice. It was dark, gray and black. I stopped the car. The wolf began to move cautiously along the iced bank towards me. I could see the amber of its eyes. It entered the brush along the edge of the slough and turned. It stood there, looking at me for the longest time. Then it disappeared."

Judi's life in the Alaskan wildlife began when she and her husband

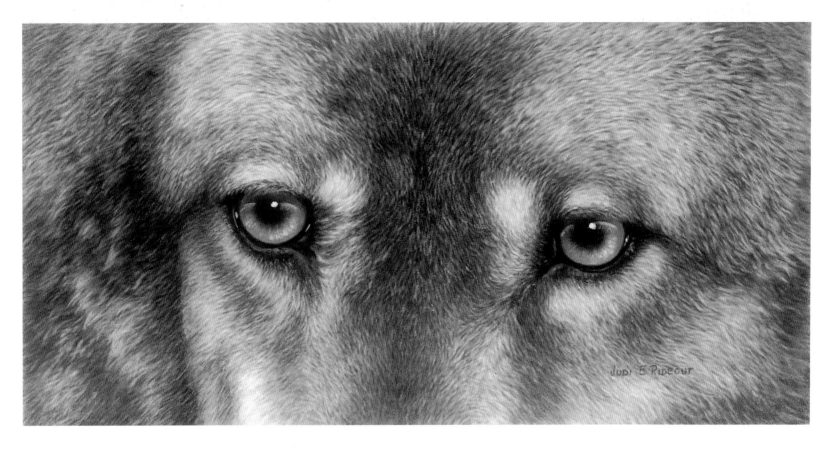

Wolf Eyes

arrived with two children, three dogs, one cat, a camper, and the desire to lead a simpler kind of life. The one and a quarter acre they purchased once belonged to a homestead family who had arrived in Alaska much the same way during the great Depression. The previous owners had drilled a well, put in a septic tank, dug a basement, and installed a bathroom and a fuel-oil-burning furnace, covered the twenty-by-twenty-four-foot basement with a leaky roof, and strung electric cable from the nearest transformer to a pole anchored in the ground.

"It was really just a leaking hole in the glacier silt. But the land had a

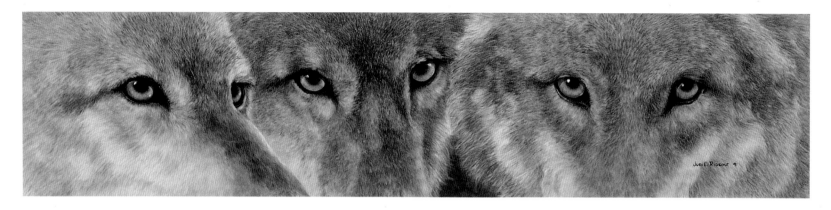

Shadows

spring-fed creek running through it and plenty of black spruce, a bridge to the road, and, best of all, thousands of acres of federal wilderness right out the back door—once we built a back door. We moved our camper off the truck and set it on the ground. We plugged into the electricity with an extension cord and did all our sleeping and cooking in the camper. Our plan was to begin construction in September. But we hadn't counted on moose-hunting season.

"Moose hunting in Alaska begins in September. All the locals—the roofer helping us repair the leaks, the lumber delivery person, the hardware suppliers, the cement truck driver—stop whatever they're doing for a month and hunt moose. Everything shut down. Ken and I couldn't do much without materials. So we did what every other Alaskan did in September and went moose hunting. By the end of the hunting season, winter had begun and you just can't do much construction once winter starts. So we plugged the leaks, put in some kitchen basics, and moved into the basement. I remember shoveling snow off the roof in a constant effort to prevent it from leaking again.

"Spring finally arrived and we went to work on the house. I was driving a school bus and Ken was cutting meat at a grocery store in Palmer. He would get home about six in the evening and we would pound nails until one o'clock in the morning. With a maximum of nineteen hours of daylight by midsummer you can get plenty of work done. But it still took us two years to complete the house. We kept running out of money. Every paycheck

would go to buy sheetrock or a sink or some window glass. It was a struggle, but we did it. We've never regretted it. It was like the start of an adventure, those first two years, that has yet to end."

Judi spends much of her time within the public wilderness area just beyond her home. "Springtime is good for cranes and moose calves. We love to spend the summer months fishing for king salmon in the Kenai River. There's nothing better than getting a king salmon on the line. Sometimes you latch on to a real goin' fish and it will take you miles down the river. My biggest was a seventy-five pounder. We like the meat smoked more than anything. But typically we will just catch and release. In the fall we go up to Denali and watch the moose in rut or follow the caribou migration. But the winter is the best time for wolves. That's when I always see tracks in the snow."

Judi and her husband enjoy hunting caribou and moose during the fall and winter season. "With just the two of us, we usually take a caribou and spend the rest of the time watching wildlife. One caribou lasts all winter long. By spring I'm usually ready to eat something else.

"I grew up hunting. My father always took me with him to hunt ducks and deer. I was never much of a shot. I finally realized that it was not because I was such a poor marksman but that I was too busy watching the animal and learning—what the animal does, how it behaves, how it reacts to other animals. It's much more rewarding than just spotting an animal and—bang!—it's dead. All you get is a dead animal. I particularly don't see the sense in hunting wolves. How does the world benefit? It doesn't. Only one person benefits from killing a wolf—the hunter. And only in that he gets a little money for the pelt. I feel the wolf hunter steals something valuable from the world, something that is not his to take. Wolves belong to no one.

"I know humans have a penchant for empowering animals with their own emotions whether it fits the reality or not. But that's what artists do. The spirit of freedom I try to express in my paintings is as much about the wolves as it is about my own sense of personal freedom in my life and art.

"If someone had told me twenty-five years ago that I would be an

Wolf Magic

artist, I would have laughed. The closest I'd ever come to creating a work of art was with a skein of ricrac and a glue gun. But when we moved to Alaska, it was as if all things were possible. I wanted to learn to draw, so I went to the art supply store in Anchorage, bought some supplies, and began to teach myself through trial and error.

"My first painting was of Pioneer Peak. I sold it for seventy-five dollars. I shudder when I think how bad it was. The framing alone was worth more than the painting. But I kept at it, driving the school bus in the morning and afternoon and working at figuring out how to draw and paint the rest of the day. In 1977, I joined an artist co-op gallery, volunteering to help out a couple of days a month in exchange for the opportunity to show my work. By 1980, my painting had improved and I began to sell fairly regularly. In the meantime, the bus company wanted to send me to a driver training center where I would learn to teach other people how to drive a school bus. Towards the end of the year, I had a big show at the gallery and sold every painting on the wall.

"I felt it was time to make some major decisions about my life, and the best place to do that was someplace far away from whatever needed deciding on. So Ken and I took a four-day rafting trip. Well, it was supposed to be four days. Our intentions were to canoe down Kroto Creek to the Susitna River, between the Talkeetna and Alaska range, where a friend would pick us up at the take-out point. Unwittingly, we put in at the wrong creek. We weren't a half day down the creek before we had to portage the raft over rocks and dry creek bed. After a day or so of lifting the inflatable over gravely mud and around huge boulders, we were tired and began dragging it along the ground. We set up camp that night, making jokes about our efforts to float a raft in a dry river, enjoying each other's company and glad just to be back in the wilderness for a while.

"That night it began to rain hard, and by morning the creek was a rushing current of debris and white water. We went ahead and put in, gliding over boulders like the ones we'd spent the last two days walking around.

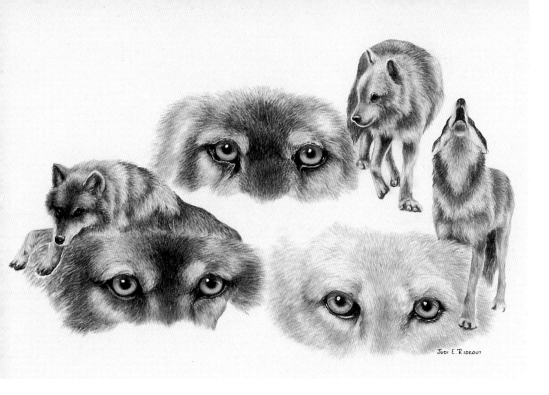

I could feel my knees knocking into the tops of them. We'd worn a few holes in the bottom of the raft from dragging it, so we spent a lot of time bailing water. We kept rounding corners and ramming into sweepers, logs that stuck out along the edge of the water, and every once in a while one of us would get knocked out of the raft. By late afternoon we were wet and exhausted. So we pulled the raft up onto the bank and set up camp.

"It continued to rain all night and into the next day. Our tent was so wet that we slept under the boughs of a big spruce tree for the next two nights, missing our take-out date but not wanting to get back onto the creek until the rain had subsided a bit. I never felt that we were in any real danger. Maybe that was foolish. We were stuck sleeping under a tree in the rain, next to a swollen waterway with bear prints tracking the muddy bank. What

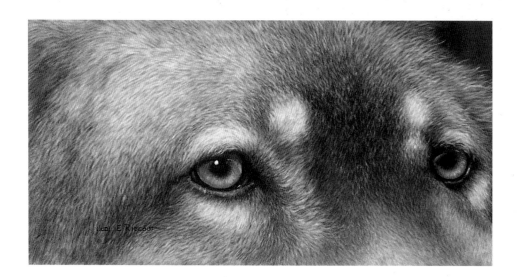

Tan Wolf

we didn't know was that our friend had filed a missing persons report when we'd not shown up at the take-out point.

"We had food, rain gear, and a place to sleep. Ken and I know what we're doing when we take an excursion into the unknown. We go prepared. It was just a matter of waiting for the water to flood out a little and then we could continue. So I spent some time relaxing and thinking about what I wanted to do for the rest of my life. Once I made the decision to spend it creating art full time, I felt an overwhelming sense of release. I sat under that tree surrounded by everything I love—my husband, the wilderness, and all the things that inspired and challenged me in the natural world. It was a wonderful epiphany."

Judi and Ken spent another three days camped along the turbulent creek. They sighted their friend flying his float plane up and down the waterway, but the banks were so wooded he wasn't able to spot them. After another day, the water seemed to have receded enough to travel safely. But once they put in, it continued to be a difficult trek. They pulled into a clearing along the bank and camped another night. The next day, their friend

flew over and saw them in the clearing and dropped them a note to let them know that assistance was on the way. A state trooper arrived in a helicopter later that afternoon and spirited them back to civilization.

"I started painting wolves with some regularity after that experience. My fascination for them grew stronger every time I would start another painting. It is extremely difficult to track a wolf in the wild, much less to get a good, usable photograph of one. I wanted to be able to spend time studying wolves up close, learning about them and photographing their expressions, especially their eyes. I began to visit wolf sanctuaries, places where wolves, unable to function in the wild for whatever reason, are accepted and cared for. These places are wonderful opportunities for everyone to learn more about wolves. I spend a lot of time just watching the wolves. In some ways, the time spent studying them is more important than photographing them. It helps me get to the essence of the painting. I would like to think that I understand much more by looking into the eyes of the wolf.

"Places in America that have lost the presence of wolves are no longer frontiers. By exterminating the wolf, humans have eliminated the spirit of freedom these places once held. Wolves make the wilderness truly wild. I can't imagine living in a world without them. Even when I don't see them, I know that they are there. And at the end of the day, it's a wonderful feeling to know, as I fall asleep, that this natural world is somehow complete.

"I am not a particularly mystical person. But I have come to embrace the spirit of the wolf that lives within the northwest coast Salish totem stories. They say the wolf bestows its happy spirit to help people. Women who obtain this spirit become skilled in creative endeavors and experience a strengthening of the senses. I would like to think there is some truth to this in my own life."

clear the way
in a sacred manner
I come
the earth
is mine
SIOUX WAR SONG

Hesitation

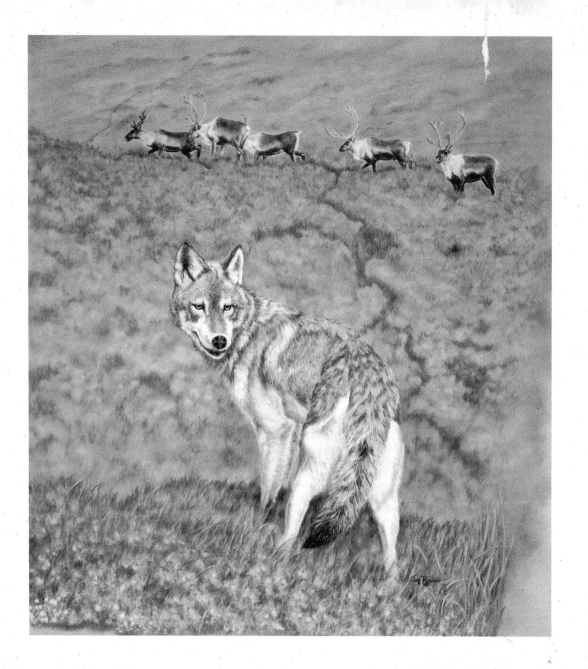

V
THE EARTH IS MINE
Repatriating the Wilderness

Our natural resources are vanishing at an alarming rate. The United States alone has seen the extinction of at least five hundred species and subspecies of plants and animals since the sixteenth century. Beginning with 1500, every year could be named after a bird or flower or mammal that has disappeared from our world, making this dire calendar an anguishing five hundred years long. But the real tragedy lies in that only the extinction of a New England marine snail can be attributed to natural causes; the loss of the other four hundred and ninety-nine appear to be the result of environmental ignorance.

Balanced on the edge of extinction and recovery are over nine hundred species and subspecies of birds, crustacea, fish, insects, spiders, mussels, snails, reptiles, amphibians, plants, and mammals inhabiting American land and water. An additional 3,700 have met the qualifications for threatened or endangered species identified by the Endangered Species Act of 1973. The ability to protect these species officially depends on the agent that may have been instrumental in adding them to the list—money. Since the passage of the ESA, the program's average annual funding has been approximately sixteen cents a year from each taxpayer—about 39 million dollars. Every year, the American government chooses between building another mile of interstate highway or protecting nature's estimated 150,000 species inhabiting the

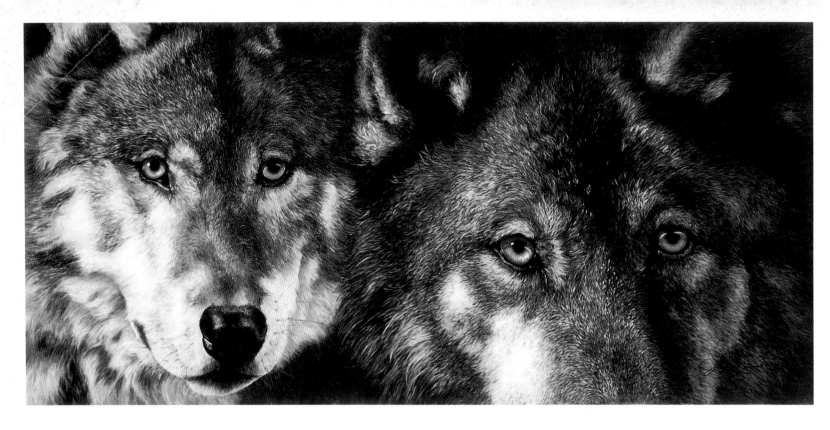

Close Encounters

United States. The price, at least financially, is the same.

The recovery of endangered and threatened species provides Americans with the opportunity to live within the real thing—a complete picture of nature rather than just the remaining pieces. It is this vitality of the natural system that is in danger of being lost, not just individual species. Relationships in nature, such as the wolf and its prey, create the links that hold this system together. The wolf, up until the 1800s, was the major predator of the North American continent. A significant number of species alive today owe many of their most spectacular traits—such as speed and agility— to their co-evolution with the wolf. To interfere with the wolf's essential

role disrupts the ongoing evolution of these species, thwarting the environment's ability to evolve naturally.

Recovery for the wolf has begun but not without a tremendous struggle. The last thirty years have witnessed a continuous uphill battle by conservationists, biologists, and wolves. Up until the late 1980s, politicians, stockmen, and sports enthusiasts—opposed to establishing wolf populations in the former ranges of the American Northwest, the East Coast and the arid Southwest—had for the most part prevailed. But throughout the conflict, the wolf has seen fit to ignore the controversy and attempt to resolve the dilemma firsthand.

Michigan's Isle Royale National Park is a forty-five-mile-long island in northern Lake Superior. The severe winter of 1948-49 provided a bridge of ice from Ontario to the island, enabling wolves in Canada to cross and feed on the moose inhabiting Isle Royale. The event resulted in the establishment of a healthy and isolated population, providing biologists with an ideal opportunity to study wolves and wolf behavior. This substantial body of data, gathered primarily by wildlife biologist L. David Mech, has broadened our understanding of wolves tenfold.

Wolves have survived in the northern Minnesota wilderness due largely to the state's proximity to Canada, where wolf populations were never entirely destroyed. Farms and ranches share the thousands of square miles that constitute the wolf's range, and despite the intermingling of wolves and stock herds, Minnesota's annual percentage of livestock loss to predation is less than one percent.

Canada has also provided a gateway to the final victory for wolf reintroduction in Yellowstone National Park. The controversy surrounding the return of wolves to America's oldest and most cherished designated wilderness caused a frenzy of political maneuvering, protectionism, and advocacy lasting almost a quarter century. The saga generated tremendous attention for the wolf, both good and bad, and raised the animal's profile to a national level. Educational programs on wolves and wolf behavior were mounted

and toured throughout the country. Rallies, public forums, and informal discussion groups were sponsored by the U. S. Fish and Wildlife Service and conservation organizations. Articles appeared in *Time, Newsweek, People, Life* and *The New York Times.* Movie stars, biologists, musicians, Native American representatives, and the general public voiced support for wolf recovery. Politicians, stockmen's lobbyists, and ranchers raised blockades every step of the way with remarkable aplomb, stretching the limits of regional political power over wild places that belonged to all Americans. But the wolf brought a resolution to the battle on its own terms. Crossing the border between Canada and Montana, wolves began to reproduce and naturally inhabit their former range. Although they were a long way from Yellowstone, their natural migration south prevailed despite antiwolf sentiments.

Once wolves stepped across the Canadian border and into America, the animals came under the jurisdiction of the Endangered Species Act. Knowing that the ESA brought a restrictive set of guidelines to the protection of species inhabiting public and private land, politicians and stockmen relented. A wolf management plan, implemented by the government and embracing the stockmen's concerns, was a far more desirable reality than living under the strict dictates of the ESA. The repatriation of the wolf to its historic northwest range was an inevitable act of nature and, with the support of the ESA, a process destined to succeed.

Biologists began the challenge of capturing live wolves from the Canadian Rockies of Alberta in January of 1995. Throughout the initial phase of the program, twenty-nine wolves were captured, fourteen for Yellowstone and fifteen for the release program in central Idaho. The Idaho wolves received a "hard" release—they were brought to the edge of the Frank Church–River of No Return Wilderness Area and immediately set free. Acclimation enclosures were prepared for the Yellowstone wolves, who spent time in three pens about an acre each in size. This "soft" release took place over a period of three months. Each enclosure was named for its location and the enclosure names were transferred to the wolves they con-

OPPOSITE

Waiting

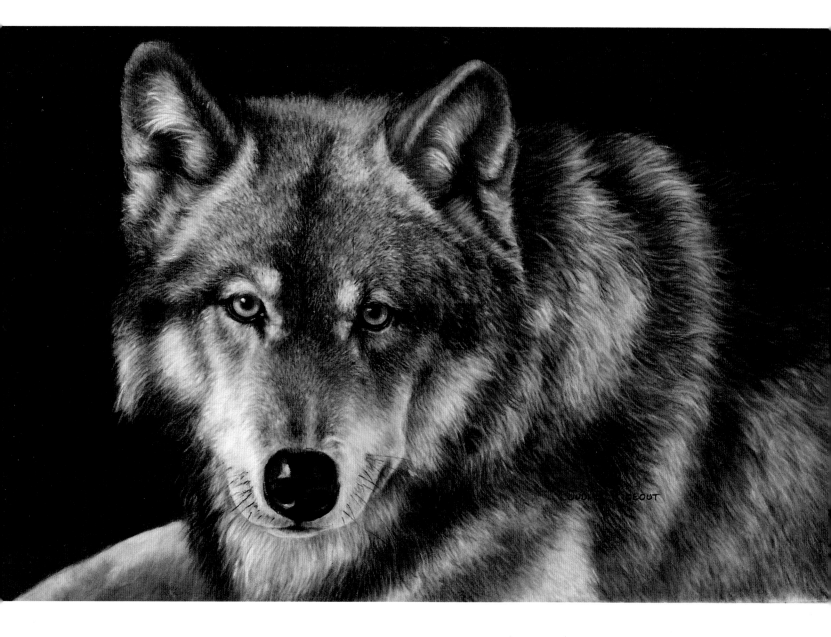

tained—the Rose Creek Pack, the Crystal Creek Pack, and the Soda Butte Pack. Once the wolves completed their acclimation period, they were released into the wilds, becoming the first known wolf packs to enter Yellowstone National Park in more than half a century.

Many endangered species are not as fortunate as the wolves of the continent's northern regions. The U.S. Fish and Wildlife Service had healthy Canadian wolf populations to draw from for their repatriation efforts. A twenty-five-year battle, such as the wolf recovery controversy in Yellowstone, could easily spell disaster for other species whose populations have severely declined. While attempts to legislate restoration perimeters drag on, efforts could ultimately dead-end in total extinction. Disease and other natural factors such as drought or severe temperatures can wipe out a delicate population in a single season. The red wolf and the Mexican wolf, at one time likely candidates for this fate, have been temporarily rescued. Without the power behind the ESA's carefully wrought language, it is very probable that these wolves would have been lost.

Efforts to rescue the red wolf from extinction began with the capture of the last known population existing in the wild. Once inhabiting a range from Pennsylvania south to Florida and west to Texas, the red wolf population had decreased dramatically by 1970. When its extinction seemed eminent, the U.S. Fish and Wildlife Service instigated a captive breeding program designed to increase the population to safe numbers and return the wolves to the wilderness. The red wolf program is an excellent example of species recovery efforts and the attendant struggle in a world of adversity.

V. Gary Henry, Red Wolf Recovery Coordinator for the U.S. Fish and Wildlife Service, remembers the capture program. "From 1973 through 1980, attempts to remove the last remaining red wolves from the wild of southeastern Texas and southwestern Louisiana resulted in the capture of over four hundred *Canis*. Of this number, only forty-three met morphological standards developed for the red wolf from museum specimens collected around the turn of the century, prior to believed substantial hybridization with the

coyote." The program concluded in 1980 with an initial population of just fourteen pure red wolves. The species was then declared extinct in the wild.

Once the capture program ended, the breeding program, designed to produce a viable population began in earnest. Sixteen years later the total new population numbered between 242 and 296. "There are currently thirty-six captive breeding facilities," Henry explains. "Two of the breeding facilities are associated with our wild reintroduction projects and are operated by the U.S. Fish and Wildlife Service. There are also two facilities operated by Point Defiance Zoo and Aquarium. One is the zoo facility itself and the other is the red wolf facility at Graham, Washington. Three island propagation projects are also breeding facilities designed to give red wolves some wild experience prior to release into mainland reintroduction sites." The program's goal, to preserve eighty to ninety percent of the genetic diversity of the species for 150 years, is believed to be attainable once it has reached a total population of 550 animals. By 1996, the breeding program resulted in 50 to 100 red wolves in reintroduction programs, 11 animals on island release sites off the East Coast of the U.S., and 181 wolves remaining in captivity.

The release program began in 1987 at the Alligator River National Wildlife Refuge in northeastern North Carolina. This 250,000-acre expanse includes the refuge as well as the U.S. Air Force Dare County Bombing Range and adjacent private lands. By 1992, the red wolf population reached thirty animals in the area, a success for the program considering the wolf's endangered status. Henry supports this evaluation. "Since management problems were resolved without long-term damage to the wolves and with little inconvenience to residents, this proved that red wolves can be restored in a controlled manner and that land-use restrictions are not necessary."

The only verified loss to a landowner by red wolves during the program involved a hunting dog. Compensation has been paid for an additional eleven goats and one chicken, based on a "good neighbor" policy that places the burden of proof on the U.S. Fish and Wildlife Service to show that the wolves were not responsible for the losses.

Denali Wolf

The Red Wolf Recovery Program is not without its problems. As history has shown, controversy regarding wolves arises not from actual livestock losses but from political squabbling. Henry explains: "Two county boards of commissioners have passed resolutions opposing the red wolf project, and the state has passed a law that became effective January 1, 1995, allowing private landowners in these two counties to kill and trap red wolves on their property if they believe them a threat and notify the service. One of these two counties is adamant in its opposition and the other was believed to be coerced into joining it in opposition. The whole situation escalated tremendously because of a law enforcement investigation of a wolf killed by a private landowner. The investigation revealed that regulations were subject to differing interpretations regarding violations. This problem was resolved in revised regulations published on April 13, 1995 that addressed the same concerns of the state law by significantly relaxing regulations. There is an organized effort by some private landowners and local politicians to stop the project. However, an attitude survey conducted recently by North Carolina State University during the period of maximum averse and inaccurate publicity revealed that the majority of the local residents support the reintroduction." It is a long road to recovery for the red wolf. But continued government and public support may ultimately prevent the animal from vanishing forever.

Wild populations of the Mexican wolf, once ranging throughout the southwest region of the continent, no longer exist in America. Its current status in Mexico is at best uncertain, and the presence of viable wild populations is thought highly unlikely. The Mexican wolf was officially listed as an endangered species in 1976, and efforts to insure its survival included a captive breeding program. The program began in 1970 with 2 males and 1 pregnant female captured in northern Mexico. Additional captured wolves were added to the program over the next twenty years. As of July 1996, the captive population included 149 animals, all descendants of just 7 animals. Despite a sound management plan, "socioeconomic concerns" repeatedly plagued efforts to implement the wolves' release.

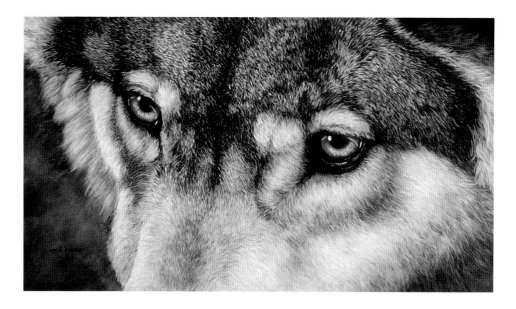

Too Close

One of the most important projects assisting in the recovery of the Mexican wolf is the Sevilleta Wolf Management Facility on the Sevilleta National Wildlife Refuge in New Mexico. The facility is designed to provide necessary space for captive Mexican wolves and an opportunity to manage and develop desirable attributes in wolves selected for eventual release into the wild.

The U.S. Fish and Wildlife Service will not release the wolves into the Wildlife Refuge. Rather, the plan calls for release into two areas that have been identified within the Mexican wolf's original range. The Blue Range Wolf Recovery Area consists of seven thousand square miles of Arizona and New Mexico and includes the Apache and Gila National Forests. The White Sand Wolf Recovery Area, four thousand square miles, includes the White Sands Missile Range in Southern New Mexico and designated Bureau of Land Management lands to the west.

David Parsons, Mexican Wolf Recovery Coordinator for the U.S. Fish

Go to the wild that waits for me;
Go where the moose and the musk-ox be;
Go to the wolf and the secret snows;
Go to my fate . . . who knows, who
knows!

<div align="right">

ROBERT SERVICE
The Nostomaniac

</div>

and Wildlife Service, leads the effort to restore the Mexican wolf to its former habitat. "The Mexican wolf (*Canis lupus baileyi*) is the southernmost most genetically unique and most endangered subspecies of the North American gray wolves." Efforts to embrace public and political support have been a significant part of the recovery program. Outreach and educational campaigns have been implemented to enlighten the region's population. Roundtable and panel discussions, trips to wolf recovery areas, published articles, open-house meetings, and public forums have assisted in informing the concerned populations living around the proposed wolf recovery areas. "Generally, Mexican wolf recovery has broad-based public support countered by strong special-interest opposition," Parson notes.

Nature has a remarkable resiliency, the result of a long, slow process called evolution. When left alone, nature tends to make sound decisions: the extinction of the dinosaur is a good example. It is a system of order as old as the earth and one in which change is the only constant. But disruptive intervention is the system's Achilles' heel and has increased with the advancement of the one species that can wreak the most damage—homo sapiens. Historically, humans have migrated across the landscape single-mindedly, oblivious to the loss of things unretrievable. Recognizing the machinations of progress and tempering the process with an informed understanding of the sacrifices are the responsibilities of an intelligent, enlightened species. Humans must continually push forward, striving for better lives and broader freedoms, but the loss of the natural world is no longer an acceptable price to pay.

AFTERWORD

The inspiration for writing this book relies as much on the remarkable talent of Judi Rideout as my own interest in protecting and preserving our remaining wilderness. I have always been an admirer of Ms. Rideout's work. She has the capacity to portray an intimacy with nature; her work captures those mystical yet fleeting moments when the boundaries between humans and the natural world collapse.

I have learned a great deal about wolves through my research for *Wolf Walking*. But as I progressed, these lessons grew to embrace more than one species. The uneducated assumptions, naiveté, and unreasonable hatred that caused the wolf's decline in America have become familiar burdens that haunt every aspect of conservation. They are emotions and attitudes easily transferred to other species and environmental issues.

Wolf Walking is a reasonable approach to one of the most controversial issues in environmental conservation. It is a book that attempts to portray adequately a remarkable and important predator integral to the American wilderness. It is also about an animal that has inspired the spectrum of human sensibilities—an animal despised, embraced, and deified.

I am by no means a wolf expert. That distinction belongs to the scientists who have spent their lives studying the animal, and this book would not have been possible without their invaluable research. Rather, I am a writer and an avid outdoorsman sheltering the hope that *Wolf Walking* will join the ranks of other publications that have helped promote a healthier, more responsible relationship with our natural world.

BIBLIOGRAPHY

Alaska's Magnificent Parklands. National Geographic Society, 1984.

Alden, Peter. *The Peterson First Guide to Mammals.* Boston: Houghton Mifflin Company, 1987.

Alligator River Wolf Project. Activities of Reestablishment Project during June 1996. United State Government Memorandum, 1996.

Barbeau, Marius. *Totem Poles.* Bulletin no. 119, vol. 1, Anthropological Series no. 30. Canadian Museum of Civilization.

Becker, Howard, and Harry Elmer Barnes. *Social Thought from Lore to Science.* vol. 2. New York: Dover, 1961.

Bierhorst, John. *In the Trail of the Wind: American Indian Poems and Ritual Orations.* New York: Farrar, Straus and Giroux, 1971.

Bossy, John. *Christianity in the West, 1400–1700.* Oxford University Press, 1985.

Botkin, Benjamin Albert. *A Treasury of Western Folklore.* Crown Publishers, 1975.

Bourne, Joel. "Hyde County's Wolf War." *Defender,* vol. 70, no. 2. The Defenders of Wildlife. Spring, 1995.

Brown, David E., ed. *The Wolf in the Southwest: The Making of an Endangered Species.* Tuscon: University of Arizona Press, 1984.

Brown, W., P. Hoban, D. Parsons, T. Stans. *Mexican Wolf Management Facility at Sevilleta National Wildlife Refuge.* National Wildlife Refuge System, U.S. Fish and Wildlife Service, 1996.

Chadwick, Douglas H. "Dead or Alive—The Endangered Species Act." *National Geographic,* vol. 187, no. 3 (March 1995).

Chase, Alston. *Playing God in Yellowstone: The Destruction of America's First National Park.* Boston and New York: Atlantic Monthly Press, 1986.

Crisler, Lois. *Arctic Wild.* New York: Harper & Row, 1973.

Demetracopoulou, D., *Wintu Songs.* Anthropos, vol. 30. Salzburg: Anthropos Institute, 1935.

Densmore, Frances, and Robert P. Higheagle. "Teton Sioux Music." *Bureau of American Ethnology Bulletin* 61. Smithsonian Institute, 1918.

Ellerbe, Helen. *The Dark Side of Christian History.* San Rafael: Morningstar Books, 1995.

Fischer, Hank. *Wolf Wars: The Remarkable Inside Story of the Restoration of Wolves to Yellowstone.* Montana: Falcon Press,1995.

Fox, Michael W. *The Soul of the Wolf.* Boston: Little, Brown and Company, 1980.

Gardner, Helen. *Art Through the Ages.* Rev. ed.Horst de la Croix and Richard G. Tansey. New York: Harcourt, Brace & World, 1970.

Gerhart, Marlene. "The Mexican Wolf." *Wolf Song of Alaska Newsletter,* Summer 1994. Anchorage: Wolf Song of Alaska.

Grant, Bruce. *Concise Encyclopedia of the American Indian.* New York: Bonanza Books, 1989.

Greeley, Maureen. "Alaska's Wolves: Majestic or Maligned." *Wolftracks,* vol. 10, no. 4. Tenino, Washington: Wolf Haven International, 1993.

Grinnell, George Bird. *Pawnee Hero Stories and Folk-tales.* Lincoln: University of Nebraska Press, 1961.

Haley, J. Evetts. *The XIT Ranch of Texas and the Early Days of the Llano Estacado.* University of Oklahoma Press, 1953.

Harrison, Jim. *Wolf: A False Memoir.* New York: Bantam Doubleday Dell, 1971.

Henry, V. Gary, Red Wolf Recovery Coordinator, U.S. Fish and Wildlife. Personal communication, 1996.

Kupper, Winifred. *The Golden Hoof, The Story of the Sheep of the Southwest.* New York: Alfred A. Knopf, 1945.

Leopold, Aldo. *A Sand County Almanac: With Essays on Conservation from Round River.* New York: Ballantine Books, 1970.

Link, Michael, and Kate Crowley. *Following the Pack: The World of Wolf Research.* Stillwater: Voyageur Press, 1994.

Lopez, Barry Holstun. *Of Wolves and Men.* New York: Simon & Schuster, 1995.

Mails, Thomas. *The Mystic Warriors of the Plains.* New York: Doubleday, 1972.

Manuel, John. "Red Wolf Showdown." *Audubon.* March–April, 1995. The Audubon Society.

Masters, Darrin. "Wolf Species and Sub Species." *Wolf Song of Alaska Newsletter,* Summer 1994. Anchorage: Wolf Song of Alaska.

Maughan, Ralph. *History and Status of the Yellowstone Wolf Reintroductions and Overview of the Central Idaho Wolf Reintroductions.* Maughan Wolf Report. 1996.

McPhee, John. *Coming Into the Country.* New York: Farrar, Straus and Giroux, 1978.

McPherson, James M. *Battle Cry of Freedom: The Civil War Era.* Oxford University Press, 1988.

McIntyre, Rick. *A Society of Wolves: National Parks and the Battle Over the Wolf.* Stillwater: Voyageur Press, 1993.

McIntyre, Rick, ed. *War Against the Wolf: America's Campaign to Exterminate the Wolf.* Stillwater: Voyageur Press, Inc. 1995.

Mech, L. David. *The Way of the Wolf.* Stillwater: Voyageur Press, 1991.

—. *The Wolf - The Ecology and Behavior of an Endangered Species.* Minneapolis: University of Minnesota Press, 1981.

Mowat, Farley. *Never Cry Wolf.* Boston: Little Brown & Co., 1963.

Murie, Adolph. *A Naturalist in Alaska.* New York: Devin-Adair Company, 1961.

Nash, Roderick. *Wilderness and the American Mind.* New Haven: Yale University Press, 1973.

Parsons, David R., Mexican Wolf Recovery Coordinator, U. S. Fish and Wildlife Service. Personal communication, 1996.

Phillips, Michael K. and V. Gary Henry. *Comments on Red Wolf Taxonomy. Conservation Biology,* vol. 6, no. 4. December, 1992.

Rausch, Robert A. *The Wolf in Alaska.* Alaska Department of Fish and Game, Wildlife Notebook Series.

Red Wolf Reintroduction—Alligator River National Wildlife Refuge. National Wildlife Refuge System, U.S. Fish and Wildlife Service, 1996.

Refsnider, Ron. "Upper Midwest Wolf Recovery: The Countdown Begins." *International Wolf,* vol. 4, no. 3. The International Wolf Center, 1994.

"Return of the Red Wolf." *National Geographic World.* National Geographic Society. October, 1990.

Samson, John G., ed. *The Worlds of Ernest Thompson Seton.* New York: Alfred A. Knopf, 1976.

Schmidly, David J. *The Mammals of Trans-Pecos Texas: Including Big Bend National Park and Guadalupe Mountains National Park.* College Station: Texas A & M University Press, 1977.

Service, Robert. *The Collected Poems of Robert Service.* New York: G. P. Putnam's Sons, 1940.

Seton, Dee Barber. Personal communication, 1996.

Seton, Ernest Thompson. *Two Little Savages.* Rpt. New York: Dover Publications, 1962.

Shepard, Odell. *The Heart of Thoreau's Journals.* New York: Dover Publications, 1961.

Sherwonit, Bill. "New Story Is Howling To Be Told." Anchorage *Daily News,* February 11, 1996.

South, Malcolm, ed. *Topsell's Histories of Beasts.* Chicago: Nelson-Hall, 1981.

Spence, Lewis. *North American Indians.* London: Bracken Books. 1985.

Stuart, David K., Park manager, Kickapoo Caverns State Natural Area, Public Lands Division, Texas Parks and Wildlife Department. Personal communication, 1996.

Taylor, Colin F., ed. *Native American Myths and Legends.* Smithmark Publshers, 1994.

—. *The Prairie.* New York: Carlton & Lanahan, 1847

Thomas, Keith. *Man and the Natural World: A History of the Modern Sensibility.* New York: Pantheon Books, 1983.

Thoreau, Henry David. *The Journals of Henry David Thoreau.* 1906. Rpt. New York: Dover Publications, 1962.

Young, Richard Alan, and Judy Dockrey. *Ghost Stories from the American Southwest.* Little Rock: August House, 1991

Wolves: Identification, Documentation, Population, Monitoring and Conservation Considerations. Northern Rockies Natural Resource Center. National Wildlife Federation, 1990.